SOMERSET AT WAR

THROUGH TIME

Henry Buckton

AMBERLEY PUBLISHING

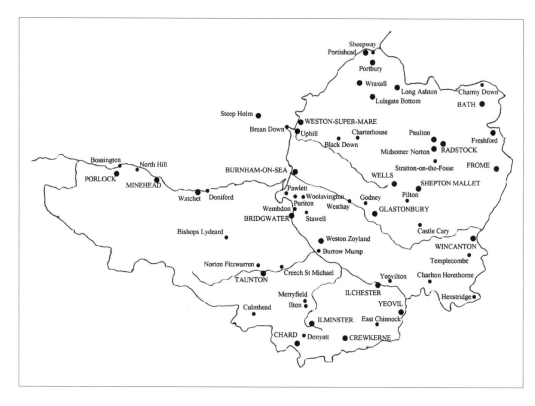

Map of locations visited.

First published 2012

Amberley Publishing
The Hill, Stroud
Gloucestershire, GL5 4EP

www.amberley-books.com

Copyright © Henry Buckton, 2012

The right of Henry Buckton to be identified as the
Author of this work has been asserted in accordance
with the Copyrights, Designs and Patents Act 1988.

ISBN 978 1 4456 0638 5

British Library Cataloguing in Publication Data.
A catalogue record for this book is available from
the British Library.

Typeset in 9.5pt on 12pt Celeste.
Typesetting by Amberley Publishing.
Printed in the UK.

Introduction

Growing up in Somerset I was fascinated by the varied structures dotted around the landscape, which my parents told me were erected during the Second World War, when the country was about to be invaded by the Nazis. In fact, wherever you go in the county you are never far away from a reminder of those wartime years. There are pillboxes, coastal defences, army camps, airfields, and many other relics of those dark days. In this book we shall be taking a geographical tour around the county, to find out exactly what was going on at the time to warrant the building of this wartime infrastructure.

Somerset's contribution to the Second World War was extremely varied and the locations we visit help to illustrate this diversity: coastal defences at places like Brean Down and Steep Holm; pillboxes built to bog the Germans down if they had invaded the South West; how the town of Glastonbury prepared itself to be occupied by enemy troops; barrage balloon trials on the Pawlett Hams; how explosives were produced at the Royal Ordnance Factory; why the town of Bridgwater sent a defiant message to Hitler; how the first jet aircraft entered service with the RAF at Culmhead; why the Taunton area was crucial to the defence of the West Country; how naval fighter pilots were trained at Yeovilton, while anti-aircraft gunners were trained at Doniford and tank crews near Minehead. We visit Downside Abbey School, the scene of one of the most tragic accidents of the entire war, and Double Hills, where the first casualties of Arnhem perished. We study the military prison at Shepton Mallet where the Americans executed some of their own soldiers; Pilton, to learn about the Women's Land Army; the important contribution made by the town of Yeovil to wartime aviation; the airfields at Weston Zoyland and Merryfield, from where American airborne forces took part in D-Day; and we see how Bath and Weston-super-Mare experienced the worst of the bombing on the county.

Henry Buckton

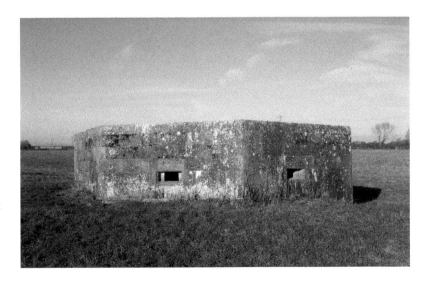

Pillbox on the Somerset Levels, near the author's home at Westhay.

Acknowledgements

Photo Credits:

Author: top 41, 43, 47, 53, 55, 58, 70, 87, 92, 94, 100, 106, 107, 116, 123, 124, 128; bottom 3, 8, 9, 10, 13, 17, 18, 19, 20, 22, 23, 24, 25, 30, 31, 32, 33, 34, 35, 36, 37, 38, 39, 40, 41, 43 44, 45, 46, 47, 48, 49, 50, 51, 53, 55, 57, 58, 59, 60, 61, 62, 64, 65, 66, 68, 69, 70, 71, 72, 77, 78, 81, 82, 83, 84, 85, 86, 87, 88, 90, 92, 94, 98, 100, 103, 104, 106, 107, 108, 113, 114, 115, 116, 120, 121, 123, 124, 126, 127, 128. Author's collection: top 5, 8, 9, 10, 13, 42, 49, 52, 61, 63, 79, 84, 97, 98, 101, 102, 104, 113, 114, 115, 118; bottom 5, 73, 75, 99, 102, 117. www. b24.net: top 69. Bundesarchiv: top 60, 99; bottom 118. Bill Caple: top 6, 15, 16; bottom 6, 15, 16. Don Cook: top 91; bottom 91. John Crockford-Hawley: top 75. Francis Disney BEM ISM: top 109, 110; bottom 109, 110. Roger Evans: top 72, 74. Peter Fitzmaurice: top 7. Peter Garwood, Balloon Barrage Reunion Club: top 31, 50, 51; bottom 52. The Helicopter Museum: bottom 7. Hestercombe Gardens Trust: top 78. Peggy Holbrow: top 80. Tim Hollinger, www.airborne506.org: top 38, 62, 64, 68. Edward Johnson: top 11, 12, 14, 17, 18, 75; bottom 11, 12, 14. Dom Leo Maidlow Davis, Downside School: top 105; bottom 105. Duncan Lucas: top 90. Carole Miller: bottom 79. Jan Morland: top 48. George Morley Collection via John Penny: top 34, 35, 82. Iain Murray: bottom 54. Rodney Pearce: top 77. Wendy Rennison: bottom 80. Lorna Rundle: top 81. Severnside Aviation Society: top 19. Graham Toms: top 45, 76; bottom 76, 101. Charles Wilkins: top 21; bottom 21. 303rd Bomb Group Association: top 20; bottom 89. Michael Virtue, Virtue Books: top 22, 23, 24, 25, 27, 28, 30, 32, 33, 36, 37, 39, 40, 44, 46, 54, 56, 57, 59, 65, 67, 71, 73, 83, 93, 95, 96, 108, 117, 119, 120, 121, 122, 126; bottom 42, 56, 67, 74, 93, 95, 96, 119, 122. Robin Walker: top 86; bottom 97. Watchet Market House Museum: top 66. E. J. Wilbourne: top 125; bottom 125. Ken Wilkinson: top 103. Andrew Wilson/Kenneth Allsop Memorial Trust: top 26, 29; bottom 26, 27, 28, 29. Wikipedia Creative Commons License: top 88, 89, 127; bottom 63. Ken Wilkinson: top 85. Peter Yeates: top 111, 112; bottom 111, 112.

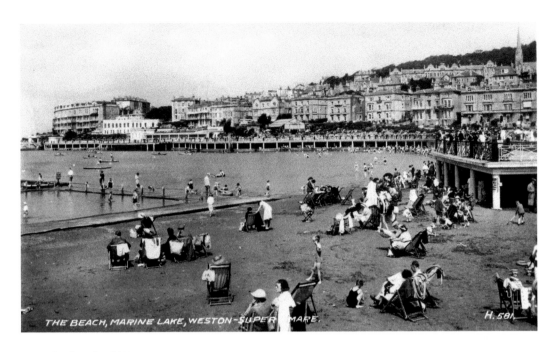

THE BEACH, MARINE LAKE, WESTON-SUPER-MARE. H. 581

Outbreak of War

We begin our journey on the coast at Weston-super-Mare which, in the summer of 1939, was bustling with holidaymakers as shown in the pre-war postcards above and below. On 3 September the prime minister, Neville Chamberlain, announced to the nation that we were at war with Germany. The people of Weston along with the rest of Somerset got used to rationing, living in the blackout, putting on their gas masks and digging for victory. Before long evacuees arrived to escape the anticipated bombing of London but, as it turned out, Weston-super-Mare was far from being a safe haven.

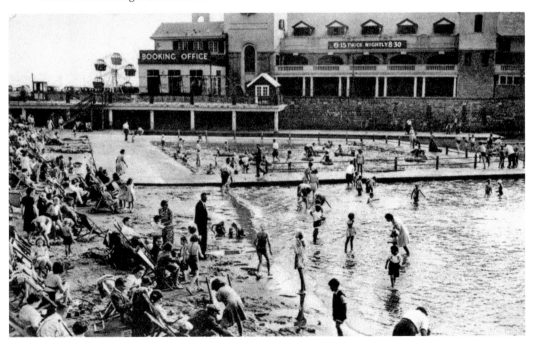

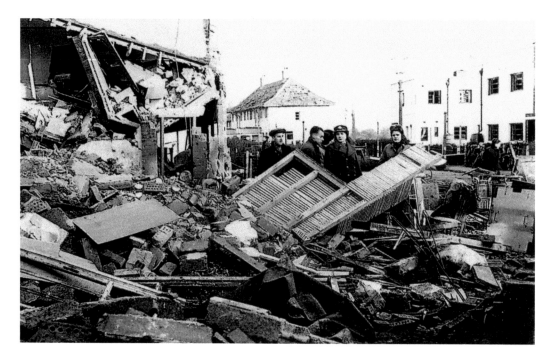

First Major Bombing of Weston

The first really serious attack on Weston took place on 4 January 1941, when at around ten o'clock in the evening aircraft appeared over Sand Bay. Instead of continuing up the Severn Estuary towards Bristol, as would be expected, the bombers turned inland and launched a heavy attack across the town. Over thirty people were killed during this raid, including several evacuee children, and more than eighty others were injured. These photographs show some of the devastation that was caused in Stonebridge Road on the Bournville Estate.

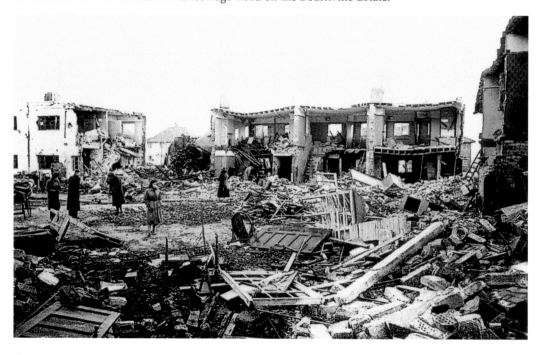

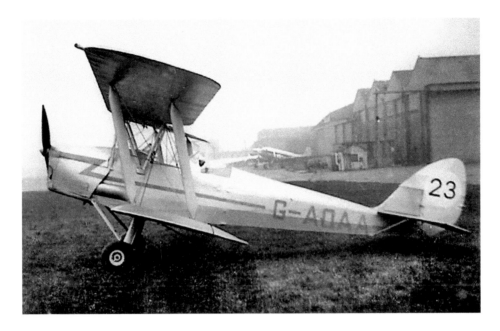

The RAF at Weston

Weston was involved with the war effort in a number of different ways. First there was RAF Locking, home of No. 5 School of Technical Training. Weston also had a civilian airfield requisitioned in May 1940 for service with the RAF. At one time this was an initial training facility for men who wished to join the RAF as pilots. For this purpose Tiger Moths were kept at the airfield as seen above. From April 1944 the aerodrome accommodated the staff college of the Polish Air Force. Today the town's renowned Helicopter Museum is housed on part of the original site (below).

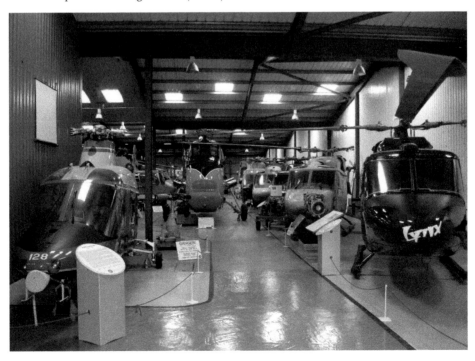

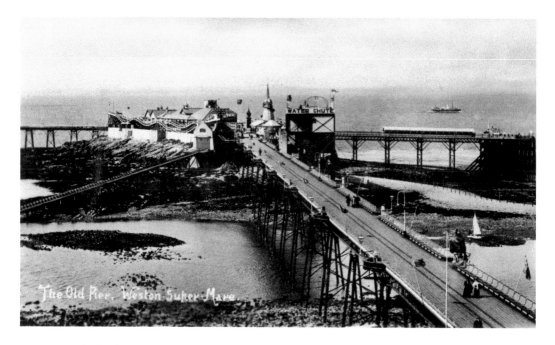

Secrets at Birnbeck Pier

In 1941, Birnbeck Pier was derelict, similar to today, when it was commissioned into the Royal Navy as HMS *Birnbeck* and taken over by the Department of Miscellaneous Weapons Development. This was a group of scientists who developed and researched top-secret nautical defence projects such as Baseball, the naval version of the bouncing bomb. A catapult was erected at Middle Hope Cove from where the bomb could skip over the surface of the water. But despite the best efforts of those involved it was never brought into service. These photos show the pier in its heyday and in its current state.

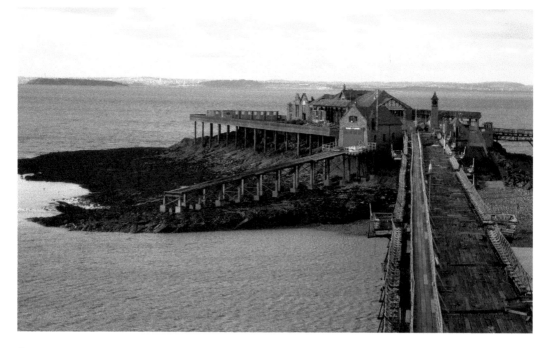

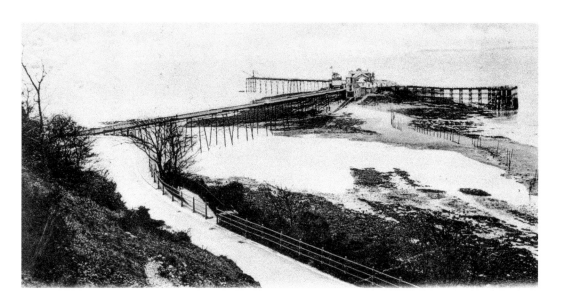

PLUTO

One of the department's many successes was Hedgerow, a mine-clearing device first tested on Berrow Flats, where hundreds of captured German mines were laid and then cleared by firing the Hedgerow bombs from boats offshore. Birnbeck also played a small part in the development of PLUTO, the 'Pipe Line Under The Ocean', a brilliantly simple way of supplying the Normandy beachhead with petrol. Trials to test the unwinding of the pipe line were carried out from the end of the pier. Above we see another pre-war view of Birnbeck, this time in its derelict state and below the same scene today.

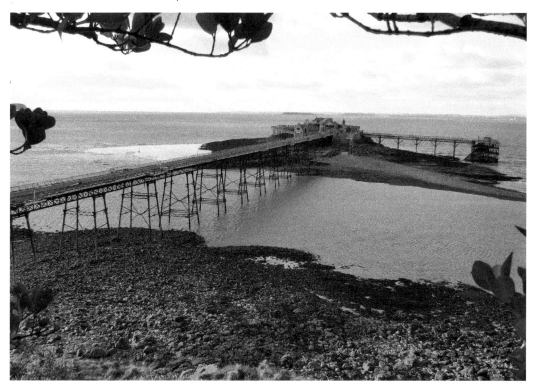

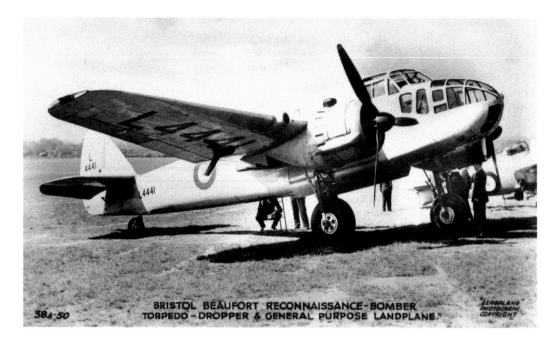

BRISTOL BEAUFORT RECONNAISSANCE-BOMBER
TORPEDO-DROPPER & GENERAL PURPOSE LANDPLANE.

"AEROPLANE" PHOTOGRAPH COPYRIGHT

38A-50

Building Aircraft

There were also two aircraft factories in the Weston area established by the Bristol Aeroplane Company as shadow works to their main site at Filton. One of these was at Old Mixon, where you can still see some of the original buildings (below), and the other was at Banwell. Between them these two factories went on to produce over 3,000 aircraft during the war. Many of these were either variants of the Bristol Beaufort (above) or the Bristol Beaufighter, which was designed as a night fighter specially equipped to deal with Luftwaffe raiders in the hours of dark.

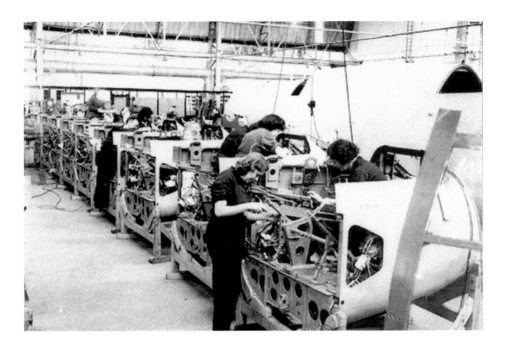

Women at Work

Towards the end of the war the Bristol Aeroplane Company's factories around Weston were commissioned to build fifty Hawker Tempests. On another part of the airfield, Western Airways repaired hundreds of Avro Ansons and other training aircraft for the RAF. With most men of a certain age away serving in the forces, the job of building these important aircraft largely fell on the shoulders of local women, and in these pictures we see female employees at the Old Mixon site busy at work.

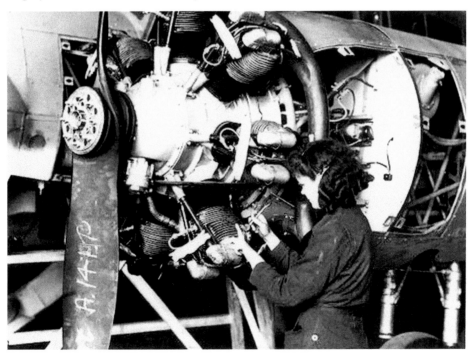

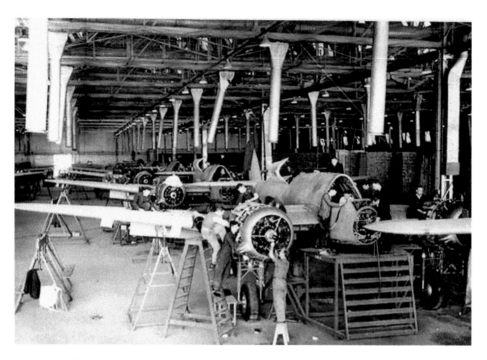

Cadet Forces

Edward Johnson, co-author of *Weston-super-Mare and the Aeroplane*, worked at Old Mixon from 1941 to 1944 (above). He was also a member of the local Air Training Corps unit, No. 159 Squadron, pictured below. The National Advisory Youth Council and the Board of Education encouraged local councils to expand all cadet organisations. These included the Army Cadet Force, Sea Cadet Corps and the Air Defence Corps, which in 1941 became the ATC. Having been a cadet himself, when Edward joined the RAF in 1944, the ATC had helped to prepare him for wartime service.

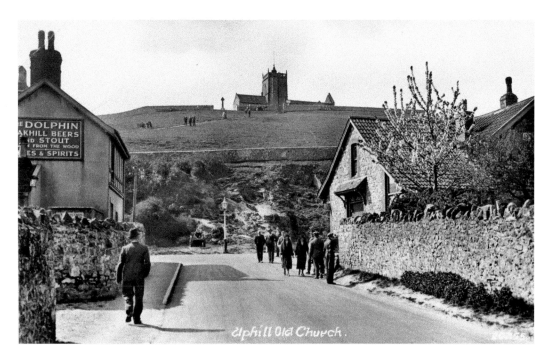

Uphill Old Church.

The Weston Blitz

By far the worst of the raids on Weston-super-Mare took place on the nights of 28–29 June 1942. On the first of these the sirens sounded at about 1.20 a.m. as over fifty German bombers carried out a concentrated attack on the town. On this occasion the affected areas included Moorland Road, Montpelier East and Southside. Uphill Church, pictured above in a pre-war postcard and again below as it appears today, was among the well-known landmarks to be hit. The above photograph illustrates that, contrary to some local claims, the roof of the church was gone before the bombing, not during it.

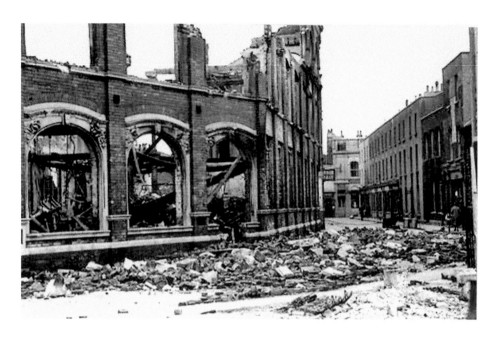

A Town in Ruins

By the end of the first raid many of Weston's streets were impassable. Civil Defence personnel from all over Somerset descended on the scene and searched through the rubble for survivors, as the fire brigade damped the smouldering ruins. But the ordeal was far from over. Just after midnight the raiders returned to finish the job. This time they appeared intent on ripping the heart out of the town. At one point the whole of the High Street seemed to be on fire. Around fifty shops and offices were destroyed (above). The Tivoli Cinema (below) was another casualty of the raids.

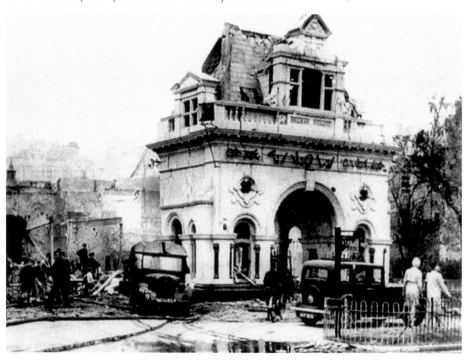

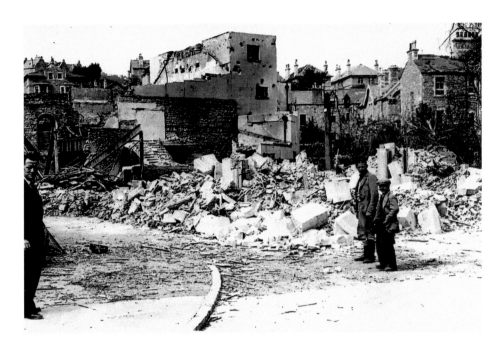

A Place Which Once Entertained

The photograph above shows what was left of the Tivoli Cinema before its remains were eventually cleared away; a sad end to a venue that had provided so much joy to so many people, entertaining tourists and townsfolk alike with the latest films. Below is the same spot in the Boulevard today. Also totally destroyed was the huge Lance & Lance department store on the corner of Waterloo Street and the High Street, as was Marks & Spencer's. In the same area two churches were burnt out, two pubs, a billiard hall and a large bakery, among other premises.

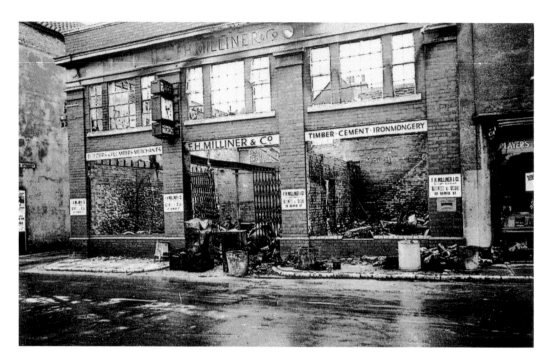

Damaged by Incendiary Bombs

The photograph above of F. H. Milliner & Co. shows the effect of incendiary rather than high-explosive bombs. There would appear to be very little structural damage, as in some of the other examples we have seen. If you look carefully at the clock on the front of the building, it gives us the time the blast happened, around 2.30 a.m. This shop was on the corner of Oxford Street and Gloucester Street and was almost directly opposite the Weston Fire Brigade HQ, where a control room coordinated the emergency response. Below we see the same corner now.

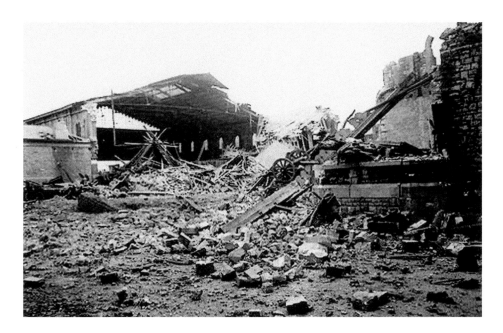

False Claims

The rail network around Weston was also affected during these raids. Above is a picture of devastation at the GWR goods yard, which once stood on the site now occupied by the Tesco store. There was also an unexploded bomb at the railway station, pictured below in modern times. This caused a temporary suspension of trains, which led to a proud boast on German radio that nothing was left of Weston-super-Mare and the railway had been totally destroyed. Surprisingly, none of the bridges over the railway line were badly damaged and the trains were running again in a few days.

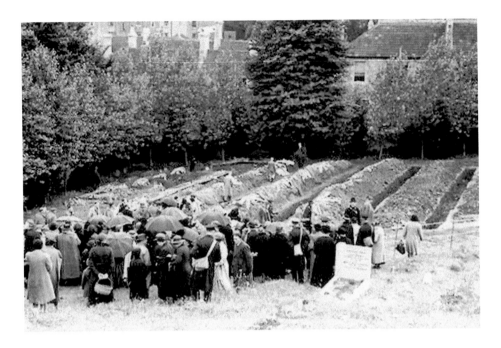

Burying the Dead

The human toll of the two nights was 102 dead and nearly 400 others wounded, many being visitors to the resort. Above we see some of the victims of the raids being buried at Weston's Milton Road cemetery, and below the same location today. Some victims were buried in mass graves, while on some separate headstones we see the names of whole families who perished together. All of those who died are listed on special plaques mounted on the town's war memorial in Grove Park.

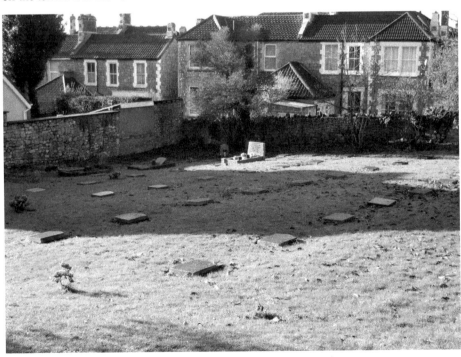

Enemy Graves

The Luftwaffe killed many innocent people in Somerset and, ironically, also in Milton Road cemetery are the graves of German airmen who died while perpetrating such acts, including the crew of a Heinkel He III shot down at Hewish near Weston-super-Mare on the night of 4 April 1941. Below is the grave of Erich Bluher, one of their number. Their aircraft was claimed by the guns of Flying Officer Ted Crew of 604 Squadron (right), while flying a Beaufighter. Crew went on to become one of the most successful night-fighting pilots of the war, accounting for twelve enemy aircraft, plus one shared kill.

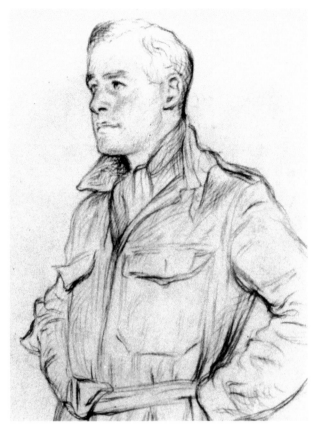

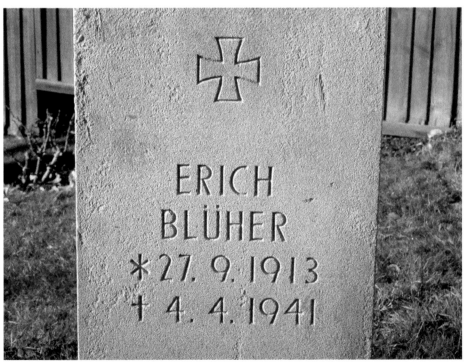

ERICH
BLÜHER
*27. 9. 1913
✝ 4. 4. 1941

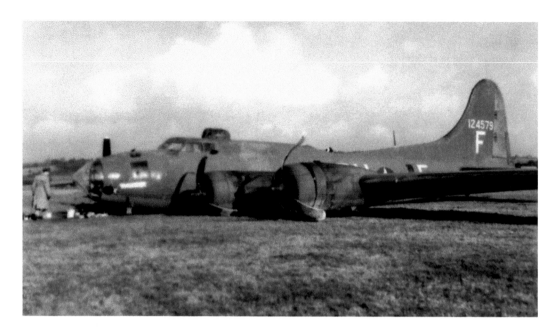

Thumper Down at Lulsgate Bottom

When Weston airfield was busy, a relief landing ground was used about 10 miles away at Lulsgate Bottom, which is now of course the site of Bristol International Airport (below). On 24 July 1941 it was visited by the red-faced crew of a German Junkers Ju88. They were returning from an attack on Birkenhead and mistook the Bristol Channel for the English Channel – they thought they had landed in France. Below we see another visitor to the airfield, B-17F Thumper of the US 303rd Bomb Group, which crash-landed here on 23 January 1943.

UXBs

Unexploded bombs – or UXBs as they were known – such as the one that disrupted rail traffic in Weston-super-Mare, had to be dealt with as quickly as possible to eliminate further danger to the public. This hazardous work was carried out by Bomb Disposal platoons of the Royal Engineers. Charles Wilkins, pictured above and below left, served in one such unit which was based in the skittle alley of the Battleaxes public house in Wraxall. His team's main responsibility was to deal with the aftermath of the Bristol air raids but they also had to respond to a large area of north Somerset.

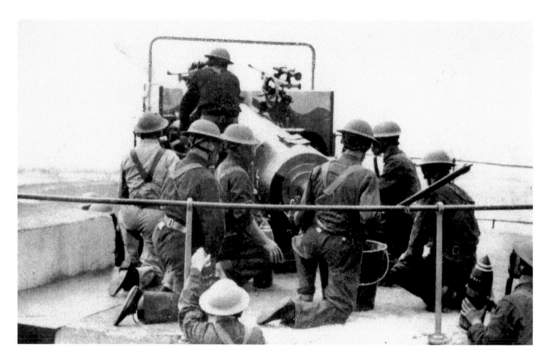

Coastal Defences at Brean Down

Moving to the south of Weston-super-Mare, the great limestone headland of Brean Down juts out into the sea. At its western tip are the remains of a Palmerston fort, built in the 1860s at a time when the country feared invasion by the French. Although the fort was abandoned in 1900, it would come to life again during the Second World War, when two ex-naval 6-inch guns of the type pictured above were installed here as a defensive measure against hostile shipping in the Bristol Channel. Below we see the gun emplacements at Brean Down.

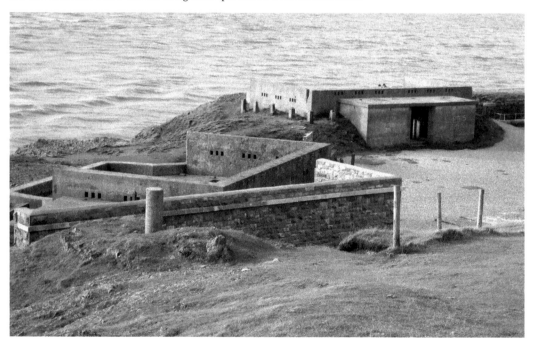

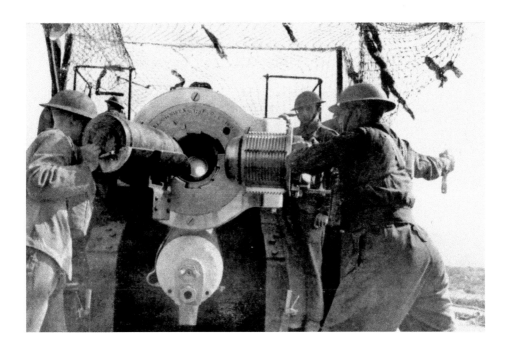

Severn Fixed Defences

In 1940, with London and the South East under constant attack, the ports in the Bristol Channel and Severn Estuary became increasingly important. To protect them from seaborne attacks a line of gun emplacements was built that stretched from Lavernock Point in South Wales, to Brean Down, with further batteries on Flat Holm and Steep Holm islands. Any ships that slipped through this blockade would face two final guns at Battery Point, Portishead. Collectively, these weapons constituted the Severn Fixed Defences. At Battery Point today (below) there are few remains other than hard-standings for the guns and remnants of a pillbox.

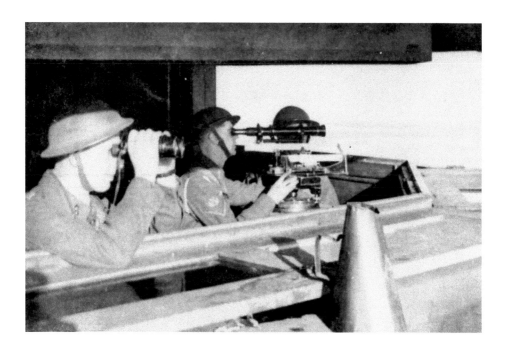

571 Coast Regiment

The guns at Brean Down were manned by 571 Coast Regiment, Royal Artillery and were controlled from a fire command bunker dug into the hillside above the fort (above and below). There were also two searchlight emplacements that worked in conjunction with the guns, their lights scanning the water at night. The officers of the regiment were accommodated in the old Victorian master-gunner's quarters, while the rest of the men lived in Nissen huts in an old quarry on the north side of the headland. The remaining Victorian barracks were used as the canteen and leisure area for non-commissioned personnel.

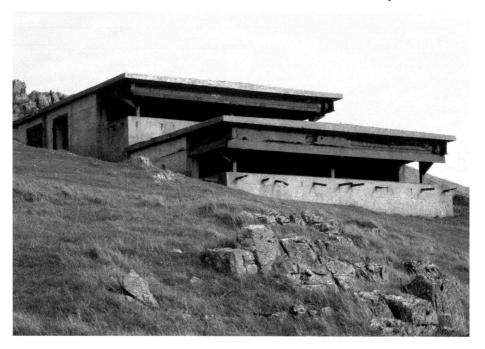

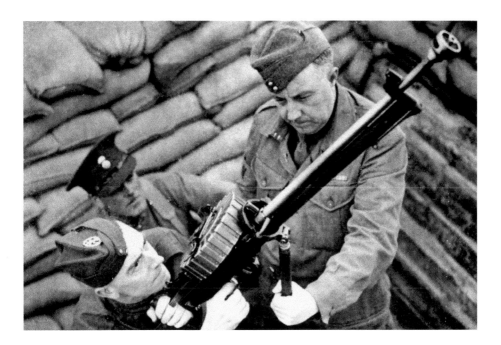

Lewis Guns Protect the Weston-super-Mare Approaches

At the end of Brean Down you will also find the remains of an 80-foot rail, which was built for the inventors at HMS *Birnbeck* and used to fire some of their rocket-propelled experiments out into the sea. Above the northern cliffs, six Lewis Guns, similar to the one manned above, were mounted in the semi-circular emplacements pictured below. These weapons covered the low-level seaward approaches to Weston-super-Mare. But the guns here, similar to the main ones at the fort, although often fired in practice, were never actually used in anger.

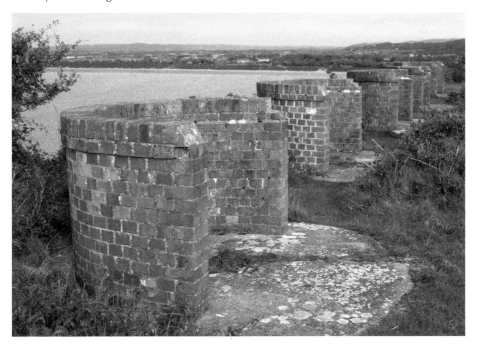

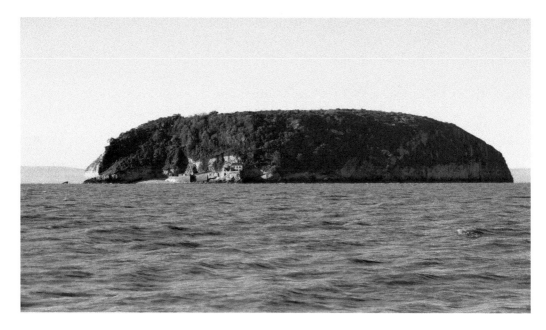

Somerset's Remotest Outpost

If life seemed dull for those at Brean Down imagine what it must have been like for the men who garrisoned Somerset's remotest outpost, the island of Steep Holm (above), where guns had also been positioned during the earlier invasion threat. In 1941, work started on upgrading the island's firepower in accordance with the current danger. Most of the initial fortification work was undertaken by the Royal Engineers, with the help of labourers from the Pioneer Corps, but also active on the island were men of the Royal Indian Army Service Corps. Below we see some of the gun emplacements today.

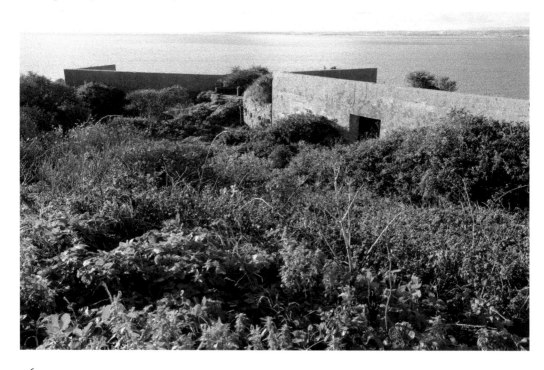

Searching for Enemy Ships

There were two batteries on the island, each armed with two 6-inch guns (above): Summit Battery, located in the north-west, and Garden Battery in the south-east. There were also a number of searchlight positions that clung precariously to the cliffs (below). One soldier died as a result of falling while on his way down to one of these searchlight posts, which nestled at the foot of 208 steps. Each battery also had its own observation post, where the guns and searchlights were coordinated with those on Brean Down and Flat Holm, the latter of which is geographically in South Wales.

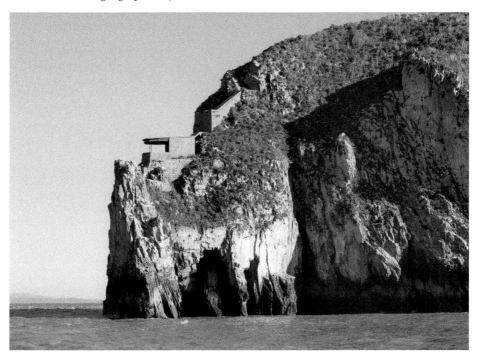

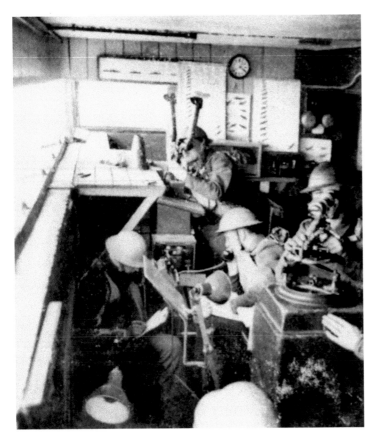

A Harsh Environment
The soldiers on Steep Holm also belonged to 571 Coast Regiment RA (above). The existing barracks were used as offices, a mess and the NAAFI. A quayside was used for unloading supplies (below), and an incline railway was built to deliver these to various points. But conditions were harsh; water was often in short supply and dirty. One soldier died of typhoid while on his way to hospital in Barry. The notorious tidal races of the surrounding Bristol Channel meant that shore leave was a rarity, and similar to Brean Down, the guns here were never put to the test.

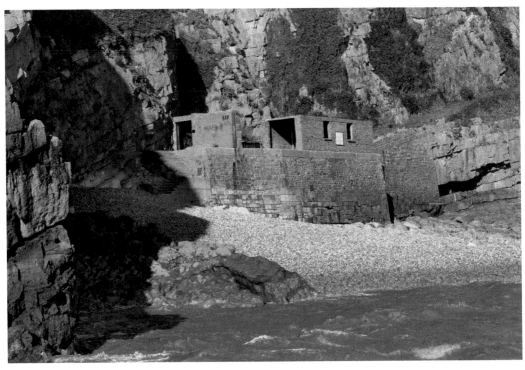

Preserved For the Future

Today the island is owned and managed by the Kenneth Allsop Memorial Trust. Andrew Wilson, the Trust's photographer, explained that the island had its own Watkin Depression Range-Finders mounted on instrument pillars. These were used to observe targets and correct the fall of shot. They needed to be reset every half hour because of the rise and fall of the tide. Above we see the remains of one of these pillars and below a Bofors gun donated to the Trust. It was subsequently discovered that there were no such weapons on the island, although they would have been seen in many other parts of Somerset.

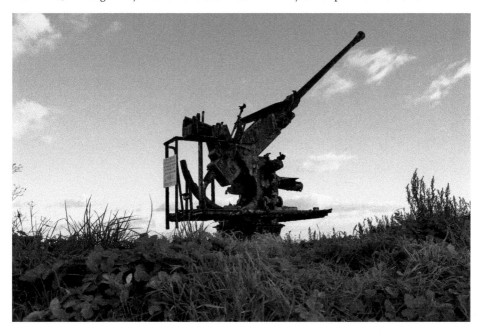

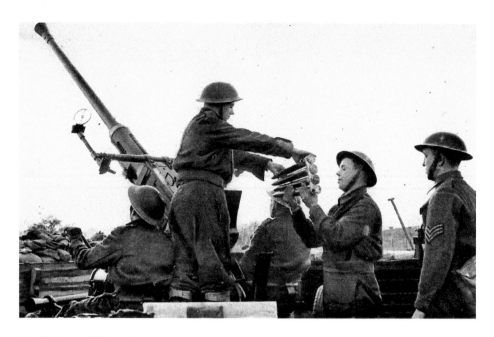

Air Defence of Bristol

The threat to the Channel ports didn't only come from the sea: a far greater danger was posed by bombing from the air, which would not only come from the coast but also from the landward side. One way of protecting Bristol from air attack was to surround it by a ring of anti-aircraft guns, some of which were situated in north Somerset, including one example near Sheepway, between Portishead and Portbury, which comprised four gun emplacements. In 1940 it was equipped with 3.7-inch guns (above). The site is today on private property but the sentry box below is still accessible along the lane.

Success from Sheepway

The Sheepway battery was later upgraded to 4.5-inch guns, but unlike the huge naval guns covering the Channel, the AA batteries in north Somerset were in frequent action. The Sheepway site claimed a Heinkel He III on 25 September 1940, which crashed between Portbury and Failand. The crew were all taken prisoner. There was also a balloon squadron at Sheepway (above). On 22 February 1941 another Heinkel He III, crippled by gunfire from a neighbouring battery, struck one of these balloons and it crashed into the mud flats at Portbury Wharf (below). On this occasion only one of the crew survived.

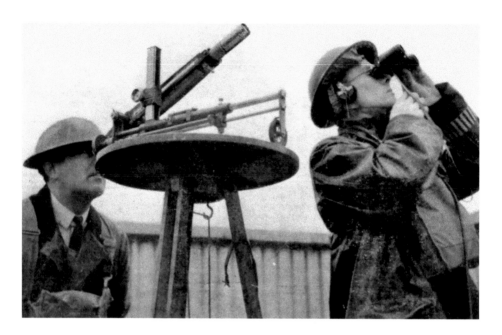

Watching for Enemy Raiders

Although there were no fighter airfields in Somerset during the Battle of Britain, many local people still contributed to the RAF's victory as members of the Observer Corps (later the Royal Observer Corps), who reported the movement of enemy aircraft from watching posts located on hilltops or high buildings (above). One of the most unusual places to accommodate such a post was the eighteenth-century windmill at Uphill (below). From here observers had a commanding view along the Bristol Channel. The individuals who manned these sites were civilians who later in the war were given RAF style uniforms to wear.

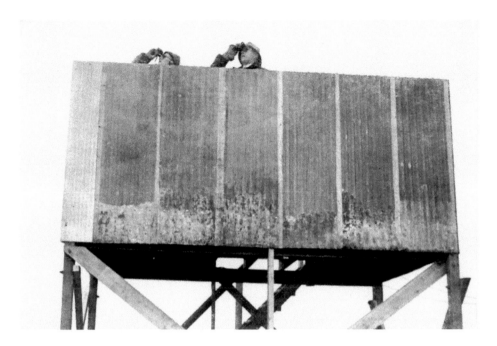

The Reporting System

At an Observer Corps post, one observer would report the movement of aircraft by telephone to an area centre – either 22 Group in Yeovil or 23 Group in Bristol – while another operated the plotter, which stood on a tripod and provided intelligence about the intruder's height, direction and speed. This information would be filtered from the area centre, to the nearest Fighter Command sector operations room, which in turn would alert the fighter stations. Posts were normally built by the observers themselves (above), which gave each a unique feel such as the more traditional example near Chard pictured below.

33

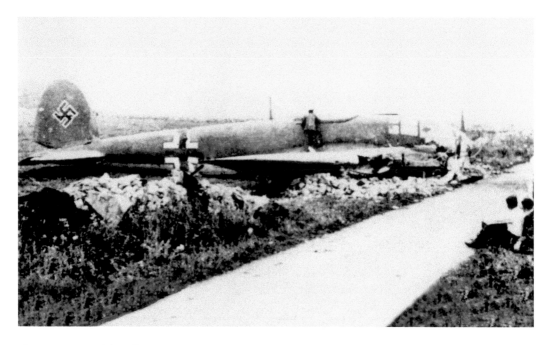

First German Raider Shot Down

On 14 August 1940, when the first enemy aircraft was shot down on to the soil of Somerset at the height of the Battle of Britain, Observer Corps teams from all over the county would have played a part in its demise. This was the Heinkel He III seen above which came to rest after ploughing through a stone wall on the Mendips near Charterhouse (below). It was one of a raiding party intercepted over the Somerset Levels near Glastonbury by Spitfires of No. 92 Squadron. The crew survived and were apprehended by members of Charterhouse Home Guard.

The Wrong Date

Here we see another view of the same Heinkel. The crew was eventually handed over to soldiers of the Gloucester Regiment stationed at Yoxter, the nearest army camp, pictured below today. In the same engagement a second Heinkel came down near Puriton and a third ditched in Sully Bay. A month later the body of one of the crew, Hans Dolata, washed ashore at Portishead. His headstone at Weston-super-Mare gives the date of his death as 12 September. This was actually the day on which he was recovered from the sea, not when he was shot down.

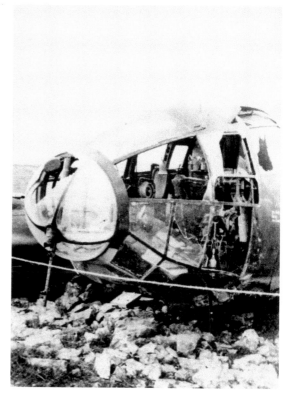

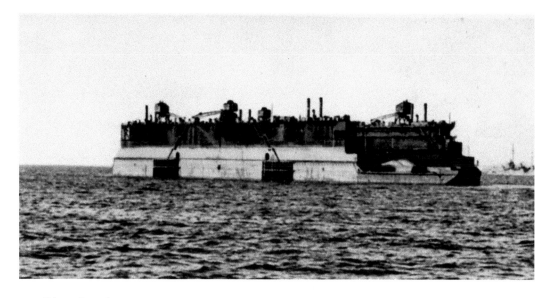

Possible Relics of D-Day

Moving further south again along the coast we come to Burnham-on-Sea, where tragically Somerset suffered its first civilian casualties of the war when bombs were dropped on 18 July 1940, killing two people. On the beach at Burnham near the old lighthouse pictured below and now partially buried in the sand, you will find what are said to be a significant reminder of the sheer scale of D-Day. Sources claim that these are the remains of thirty concrete blocks which formed part of the man-made Mulberry Harbours (above).

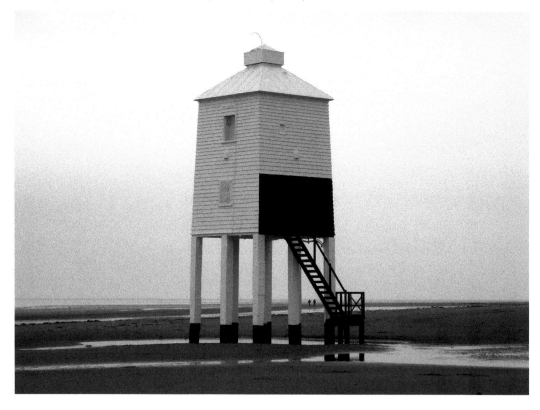

Mulberry Harbours

In planning the invasion the Allies required harbours in order to land reinforcements and supplies. They knew it would be impractical and time-consuming to capture heavily defended ports, so they decided to take their own. The Mulberries were two harbours each the size of Dover: Mulberry A supplying the American sector and Mulberry B the British and Canadian sector. They were constructed of huge concrete blocks that had been built in ports throughout the United Kingdom and towed across the Channel for assembly off the Normandy coast (above). Below we see one of the blocks on Burnham beach.

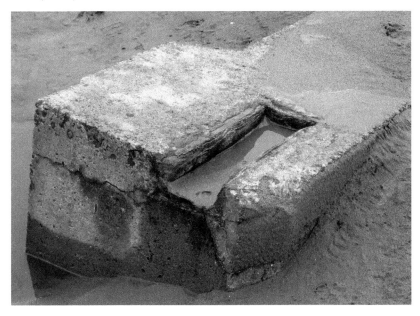

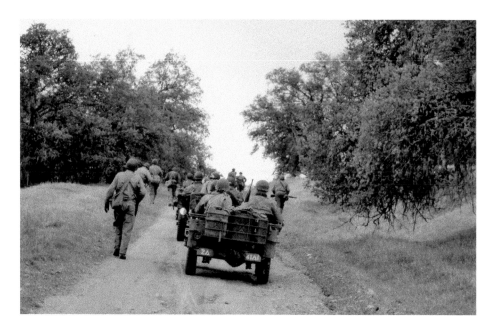

Supplying the Normandy Beachhead

Although Mulberry A was destroyed in a storm on 19 June, in the ten months after D-Day Mulberry B was used to land over two and a half million men, 500,000 vehicles and four million tonnes of supplies to the Normandy front (above). Once the war was over some of the blocks were broken up and dropped off around the coast to help bolster local sea defences. One group is said to have found its final resting place here in Somerset (below). Some eyewitnesses claim the blocks are in fact the remnants of other defences such as road blocks and tank obstacles, so perhaps the truth is a combination of the two.

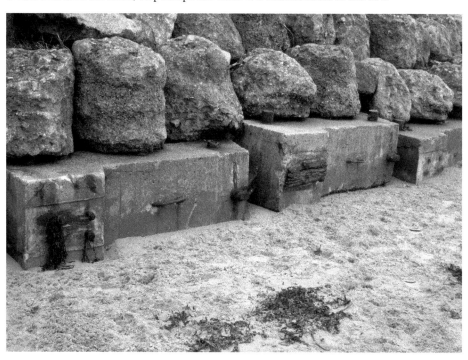

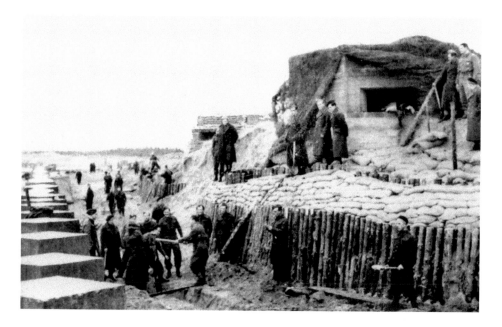

Preparing for an Invasion

In 1940 Britain feared invasion and Somerset would feature in the nation's defence strategy at that time. At the start of the war Admiral Sir Frederick Dreyer was tasked with identifying beaches across which troops could be landed. Where Somerset was concerned his team concluded that the threat was very real, particularly from an airborne assault by glider and parachute troops; so to prevent German gliders from landing, Royal Engineers dug posts into the beaches and built pillboxes along the coast, such as the one seen below on Burnham and Berrow golf course. Above, coastal defences under construction.

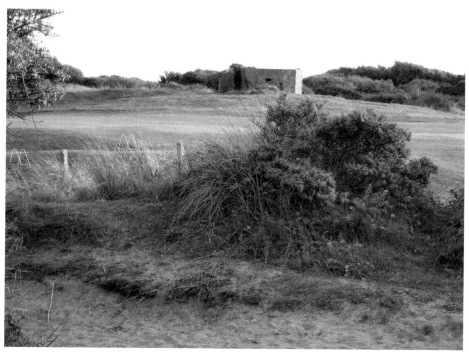

Ironside's Box

To protect London, Bristol and the Midlands in the event of an invasion, the commander of Britain's home forces, General Sir Edmund Ironside (left), devised a series of stop lines across the country. He recognised that an attack on Bristol would probably come up from Lyme Bay, and decided that the rivers, rhynes and ditches of the Somerset Levels would be the ideal place to bog the enemy down. To this end, he created a box hemmed in by three lines of defence, as illustrated in the map below, each of which included a continuous line of pillboxes.

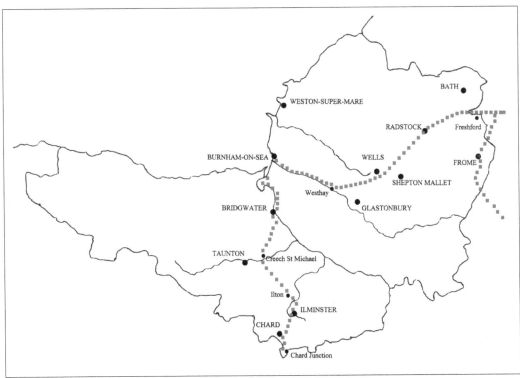

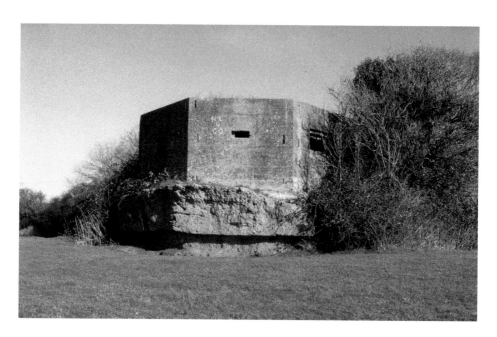

The Taunton Stop Line

The western side of General Ironside's box was called the Taunton Stop Line, which ran straight down the middle of the county from the Pawlett Hams to Chard Junction, where it crossed the county border. Along its route it made use of natural or manmade obstacles, such as the River Parrett, the Bridgwater and Taunton Canal, the old Taunton and Chard Canal, and the line of the Great Western Railway. Above are the remains of a pillbox along the Taunton and Chard Canal near Creech St Michael, and below an example guarding the GWR line between Chard and Ilminster.

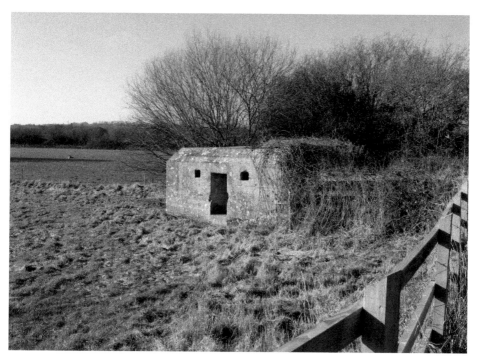

GHQ Stop Line Yellow

To the east, the GHQ Stop Line Yellow began at the confluence of the rivers Avon and Frome, near Freshford, and from there ran all the way down to the coast at Bournemouth. As well as taking in parts of Somerset, this particular line also cut across stretches of Wiltshire and Dorset. In fact, it only visited Somerset long enough to fortify Frome, pictured above in a contemporary postcard. The one thing that the builders of this line perhaps did not appreciate was the fact that the Frome Valley is a flood plain and visitors to the area today will often see its bunkers deep in water. Below we see soldiers inside a pillbox.

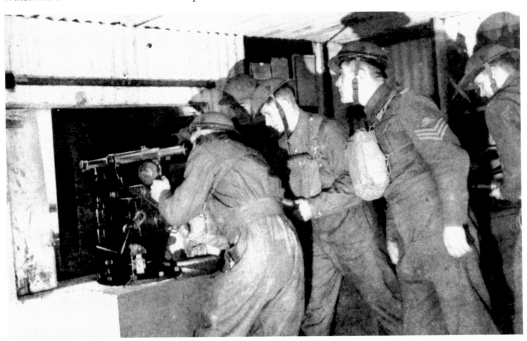

GHQ Stop Line Green

In the north, the GHQ Stop Line Green went from the Somerset coast at Burnham-on-Sea to Freshford. Along the way it followed the River Brue, Division Rhyne, its own anti-tank ditch around Wells, and finally the Somerset & Dorset Railway line from Midsomer Norton and Radstock. This was the final line of defence; if the Germans got beyond this they would soon be in Bristol. Above we see a pillbox at Godney on the Somerset Levels, and below an example that defended the rail network, which can still be seen at the museum of the Somerset & Dorset Railway Heritage Trust at Midsomer Norton.

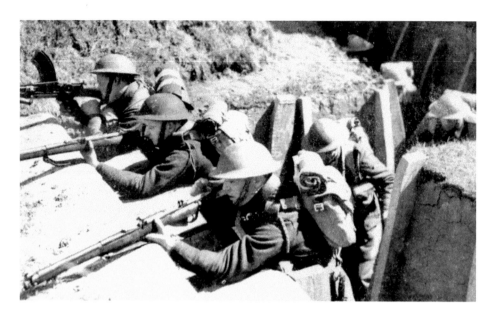

A Death Trap

These defences were designed and built by different teams. For instance, the architect of the GHQ Stop Line Green was a Captain Stiles of the Royal Engineers, who worked from an office above what is now Bekynton Brasserie in Wells Market Square. When finished, as well as having pillboxes the stop lines also constituted machine gun nests, anti-tank gun emplacements, infantry ditches such as the one shown above, and anti-tank obstacles like the dragon's teeth seen below at Donyatt. The plan was to catch enemy troops trying to break through the line in deadly crossfire.

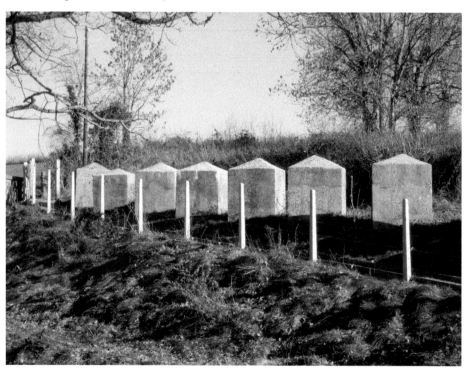

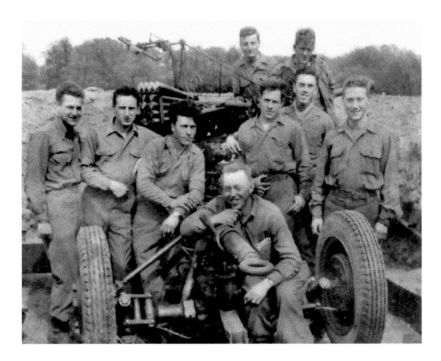

Anti-Tank Islands

Parts of the stop lines were more heavily defended than others, such as those surrounding important transport links. For example, the village of Ilton became an island surrounded by anti-tank defences, including the unusual two-storey pillbox pictured below. However, after exercises revealed their flaws, and following the departure of British troops in Somerset to make way for Americans – such as the anti-tank unit pictured above at Barwick House near Yeovil – the stop lines were largely abandoned. After the war, farmers were offered £5 for each pillbox they could demolish, but they were incredibly strong and in most cases the pillboxes won.

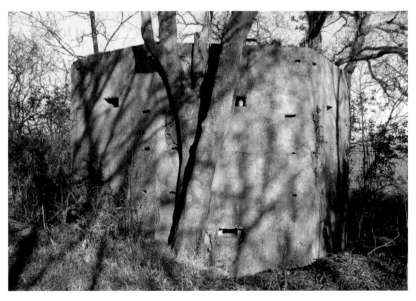

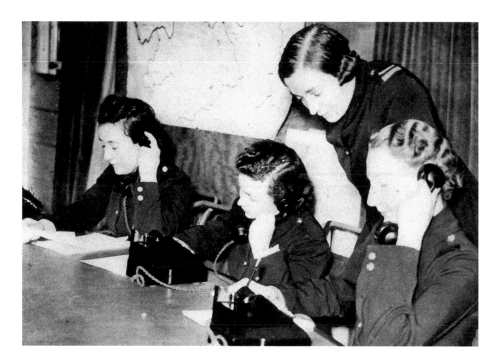

Invasion Committees

If the Germans had invaded through Lyme Bay and pushed towards Bristol, the towns and villages on the Somerset Levels, particularly Glastonbury, would have found themselves in the middle of a battlefield and normal life would have ceased. They were therefore instructed by the Ministry of Home Security to form invasion committees which would include representatives from the police, Air Raid Precautions, National Fire Service (above), Women's Voluntary Service, and many other areas of the community. Below we see Glastonbury town hall today which would have been an important wartime focal point.

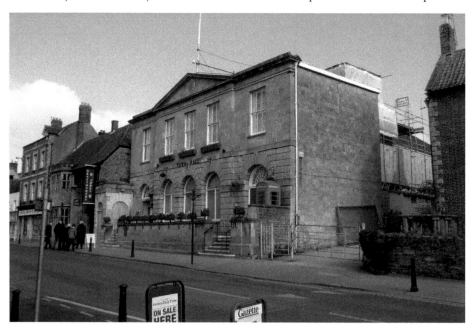

GLASTONBURY INVASION COMMITTEE WAR BOOK.

INDEX.

Invasion Committee War Book

One responsibility of these Invasion Committees was the compilation of an Invasion Committee War Book, which catalogued all available resources in an emergency. Above we see part of the index of Glastonbury's book. It listed things as diverse as food sources (below), field kitchens, water sources, and burial of the dead. This document collected dust in the icehouse of a High Street shop until it was rediscovered, along with other lost records of Glastonbury Borough Council, by a staff member when Jan Morland and her husband John were clearing out the premises in 1975 to open an art gallery.

PART ELEVEN FOOD

(a) Details of arrangements with the local Food Officer and of assistance to be given to him.

 (1) Messengers will be allocated to the Food Office and any other assistance will be called for from members of the W.V.S. and Civil Defence services.

 (2) Emergency Rations are held in case of need for distribution on "Action Stations." The Food Executive Officer has arranged for sub-depots for the issue of such rations and the Police will be called upon to assist in controlling the public and advising them of the hours and places at which this food distribution will take place.

 (3) Special Emergency Rationing may be necessary and the Food Executive Officer in consultation with the Chairman of the Invasion Committee and the military will deal with this.

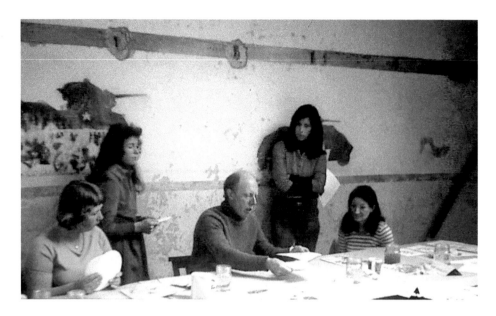

Americans in Glastonbury

Later in the war, when Glastonbury was occupied by American forces during the build-up to D-Day, they used the back of the same premises seen below as their recreational ground. Jan Morland recalls pictures of tanks painted on the walls of the billiard room as seen in the photograph above taken at the time. There was also a bar room and another room with a notice on the door stating Troop Office Keep Out. Residents also recall how the Americans began to build up in the town with vehicles lining the streets. One morning they were completely gone and they later learnt about D-Day.

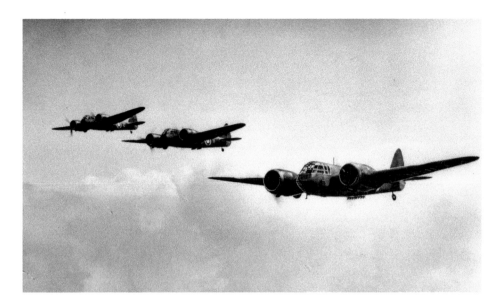

Bombing on the Pawlett Hams

The Pawlett Hams pictured below is an area of low country where the Somerset Levels meets the estuary of the River Parrett. Because so few people lived here, it was decided to use it as a bombing range for the Royal Air Force. People in nearby villages would therefore have been used to the sound of explosions. One of the worst happened on 5 July 1942, when a Bristol Blenheim, like the ones above, flying from RAF Bicester, crashed into the ground killing everyone aboard. The explosion and subsequent fire were so intense that, other than a few fragments of clothing, little was ever found of the four-man crew.

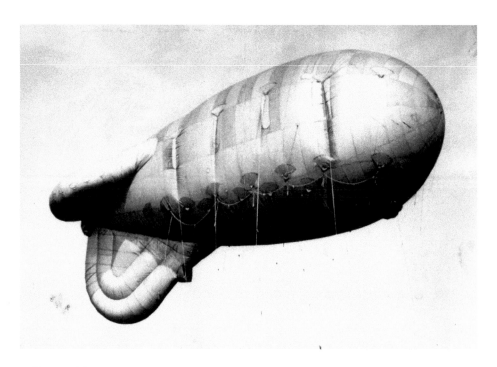

Balloon Cable Cutting

On the edge of the Pawlett Hams you will find the large shed pictured below, which was in fact a balloon hangar and an outstation of the Royal Aircraft Establishment at Farnborough. Trials in barrage balloon cable cutting were carried out here. During these experiments aircraft stationed at RAF Exeter or RAF Culmhead in the Blackdown Hills would attempt to sever the cables attached to balloons which could be so lethal to low-flying bombers, such as those illustrated above. The main work carried out at Pawlett was the testing of German cables, to help draw comparisons with our own.

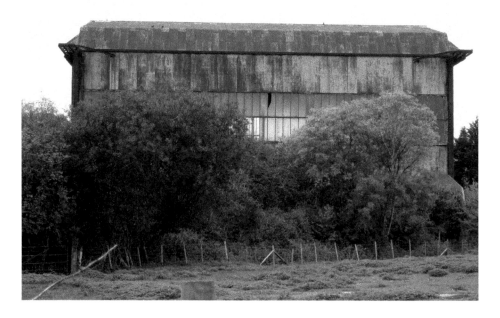

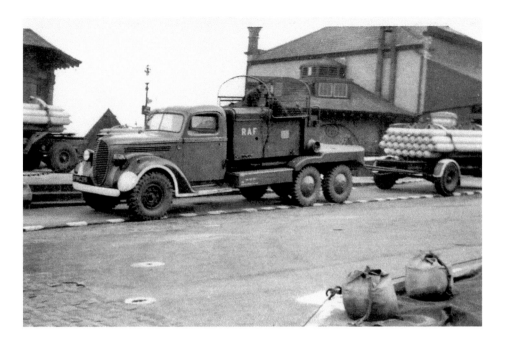

Winches

In order to carry out this vital work it was necessary to have a hangar of sufficient size to house a balloon fully inflated when not in use. Mobile winches similar to the one seen above would be employed to move balloons to and from the shed. Sometimes during exercises the balloons would be tethered to concrete pillars, one of which can be seen in the photograph below. Before the war locals recall that a red light was put on top of these to aid navigation along the River Parrett, so they were not specifically built for the unusual purpose for which they were later used.

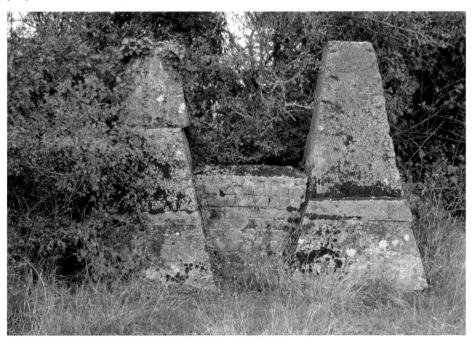

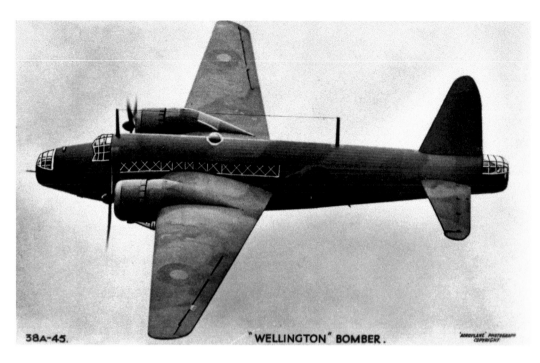

38A-45. "WELLINGTON" BOMBER. AEROPLANE PHOTOGRAPH COPYRIGHT

Sole Survivor

Pawlett was one of only two sites boasting a hangar of this size, the other being the maintenance unit at Sutton Coldfield where there were four similar sheds. However the one here in Somerset is now the only surviving example. For the pilots who carried out this work, although it was extremely hazardous, there were surprisingly few accidents. On one occasion in March 1941, a Vickers Wellington (above) became uncontrollable when one of its propellers fouled in a cable. The pilot parachuted to safety while his aircraft crashed a mile to the west of Pawlett village. Below is an illustration of cutting equipment.

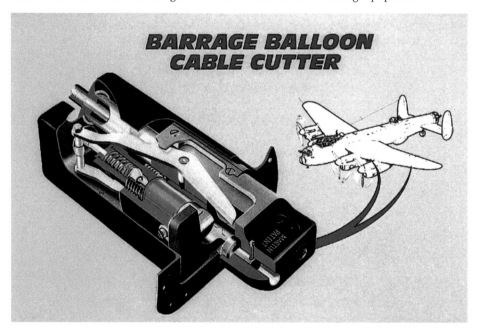

BARRAGE BALLOON CABLE CUTTER

Royal Ordnance Factory

The one thing the Somerset Levels has in abundance is water. They are drained by a network of rhynes and rivers, such as the Parrett, pictured above at Pawlett with the balloon hangar in the distance; and the Brue, seen below at Westhay guarded by a pillbox. One of the widest is the Huntspill River, yet this is not a natural watercourse; it was dug out during the Second World War to supply water to a new local industry, the Royal Ordnance Factory, situated between the villages of Puriton and Woolavington. It opened in 1941 in order to produce RDX, which at the time was a new experimental high explosive.

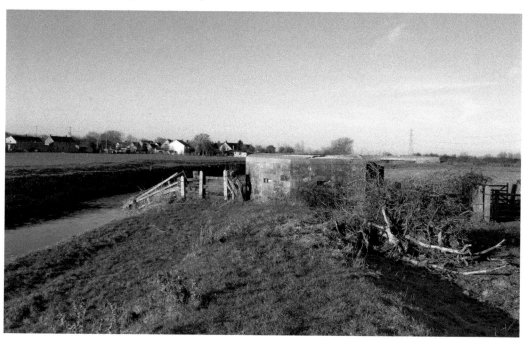

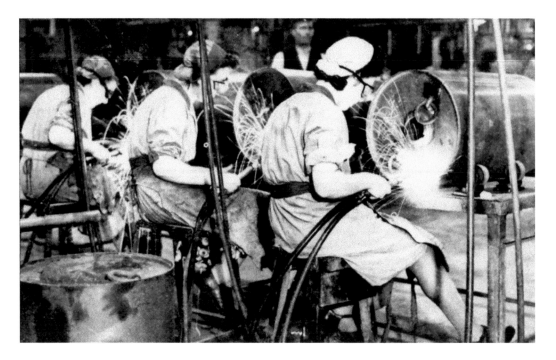

Making Explosives

RDX simply stood for Research Department Explosive. It was first invented in Germany where it was known as Hexogen. On its own it was safe to manufacture and stable in storage. It didn't become dangerous until it was put inside shells or bombs as above. The finished product would be sent to filling stations, such as the Royal Ordnance Factory at Chorley, for putting into munitions, where it was usually mixed with other explosives including TNT. The bouncing bombs used in the Dambusters Raid, for instance, as pictured below, were filled with an RDX mix known as Torpex.

The Need for More Water

In order to produce RDX, the Royal Ordnance Factory needed a guaranteed water supply amounting to several million gallons per day. The waterlogged Somerset Levels was the ideal location but as well as existing sources, it was decided to dig out the artificial Huntspill River to the north and widen the King's Sedgemoor Drain to the south. Above we see a pumping station that drew water from the Drain and below the Huntspill River. By 1943 the factory employed nearly 3,000 people and even after the war it continued to be one of Bridgwater's largest employers for many years.

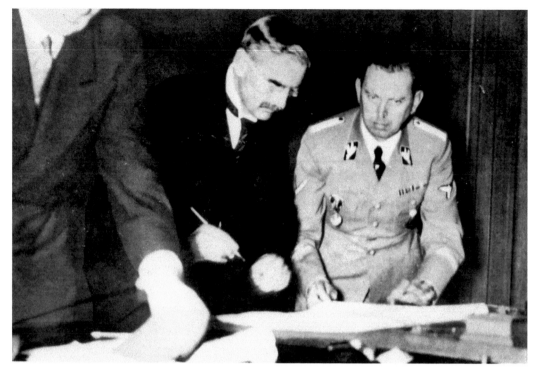

Bridgwater's Message to Hitler

In November 1938 the people of Bridgwater made an impact on the world of politics when they united against Fascism. Neville Chamberlain had only recently signed the Munich Agreement (above), which awarded the Nazis concessions in return for peace. But many people in Britain were unhappy with this and a by-election in Bridgwater gave them the opportunity to voice their concerns. The journalist and broadcaster Vernon Bartlett chose to stand as a Popular Front candidate opposed to the appeasement. Bridgwater had been a safe Tory seat but Bartlett won with a landslide, much to the government's embarrassment and the apparent annoyance of Hitler, photographed left talking with Chamberlain.

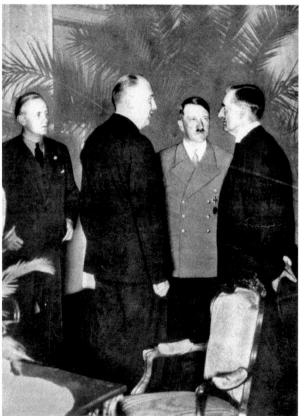

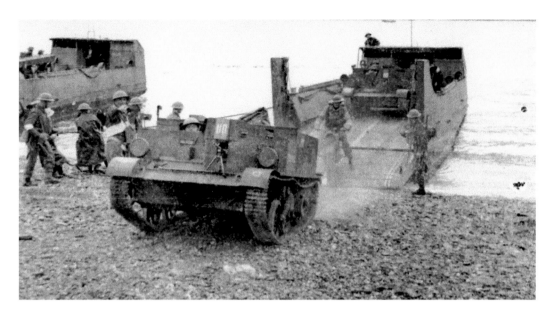

Contributing to the War Effort

Bridgwater is one of Somerset's most important industrial centres, so it is hardly surprising that many factories in the town joined the war effort. One of its largest employers was British Cellophane, photographed below in 2010, which first opened in 1937. During the war it produced film that could protect ammunition from the humidity of the Far East. It also made Bailey bridges for the army. Other items produced in the town included shell cases, electric motors for tanks, and landing craft; the latter of which by the Light Buoyant Company, which were then tested in the River Parrett (above).

Bridgwater Bombed

In spite of its industrial base Bridgwater suffered very lightly from enemy bombing compared to Weston-super-Mare and other parts of the county. By far the worst incident happened in the early hours of Sunday 25 August 1940 when a lone raider dropped around 200 incendiaries and high explosives over the town. Among the areas hit were Colley Lane (above today) and the Old Taunton Road (below today). Seven people were killed. Whether the target was British Cellophane is unknown, but in order to safeguard both this and the Royal Ordnance Factory, a decoy site was established at the foot of Pendon Hill near Stawell.

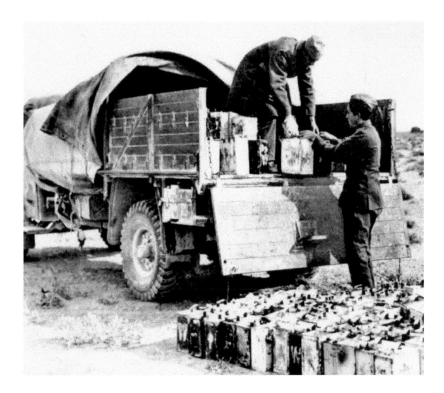

Decoy Sites

There were several types of decoy site in Somerset designed to protect airfields, industrial centres, and major towns and cities, such as the one seen below on Black Down in the Mendips. They were covered with lights, which at night could be switched on to make them look like a factory or airfield to attract the attention of enemy bombers. The lights would then be switched off again, once raiders were known to be in the area. If the ruse worked and the decoy site was targeted, barrels of fuel (above) could be ignited to make it seem as though the target was on fire.

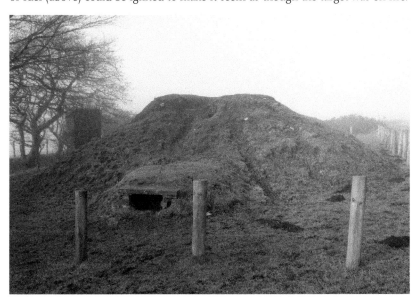

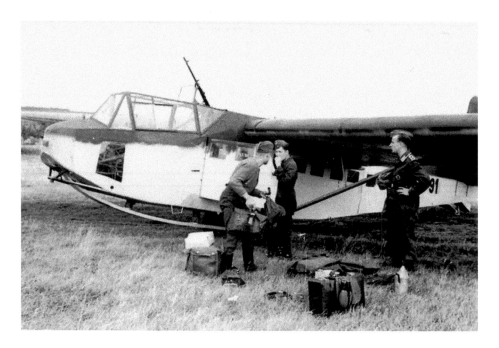

Stopping Airborne Troops

The decoy site on Black Down was known as a Starfish Decoy. It was supposed to represent a blazing Bristol following an air attack. The men who worked there operated from blast proof shelters like the one seen on the previous page, but even so it must have been extremely hazardous work. Black Down was also unusual because it was covered in strange mounds of earth as pictured below. These were set up to prevent enemy gliders, such as the type seen above, from landing on what was a relatively flat area of high ground close to Bristol.

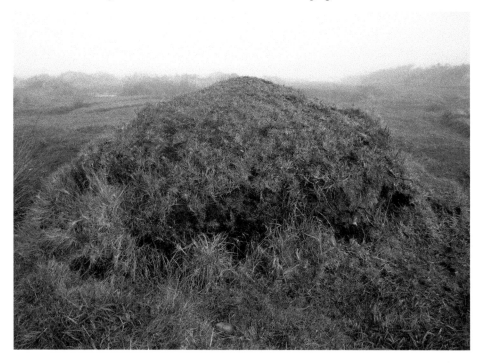

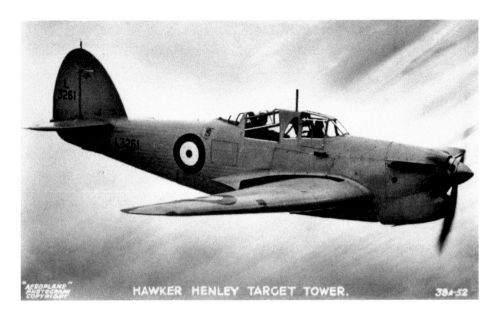

HAWKER HENLEY TARGET TOWER.

Target-Towing from Weston Zoyland

About 4½ miles to the south-east of Bridgwater, near Weston Zoyland, was another pre-war airfield, which was originally used to provide target-towing aircraft for the anti-aircraft gunnery ranges on the Somerset coast at Doniford. These aircraft, usually Hawker Henleys (above), would tow a target behind them which looked something like a shirt sleeve open at either end. When the war began the airfield became permanently occupied by a succession of squadrons on Army Co-operation duties. At first the airmen were billeted in nearby villages, until accommodation blocks were provided (below).

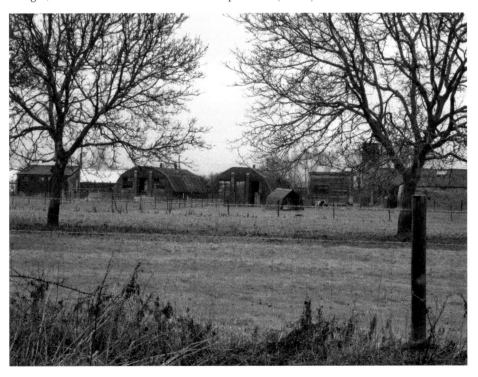

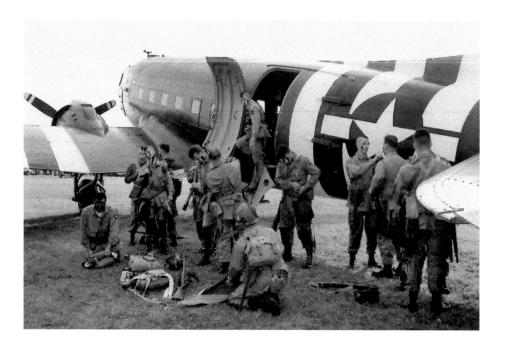

Changing Roles

Eventually the Air Ministry decided to upgrade the airfield to bomber standard and in early 1943 work began on laying concrete runways (below). However, as D-Day approached, American troops poured into the West Country, where they would train in readiness for the invasion and be close to their embarkation points. Among them were elements of the 101st Airborne Division (above). The job of transporting these paratroopers to France was given to the US 9th Troop Carrier Command, who needed airfields close to the units they would be lifting. Weston Zoyland subsequently became United States Army Air Force Station 447.

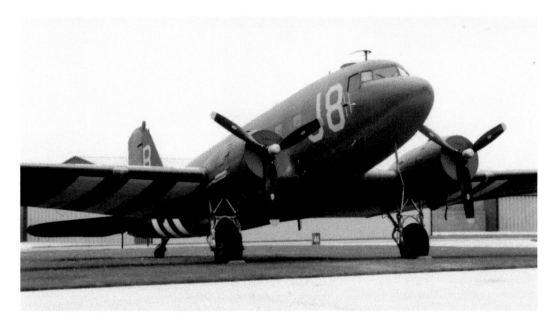

Preparing for the D-Day Drop

In April 1944, the 442nd Troop Carrier Group began to take up residence at Weston Zoyland equipped with C-47 Dakota Skytrains as pictured above and Waco gliders seen below. Over the next few weeks the people of Bridgwater became used to the sight and sound of Skytrains towing gliders over the town both day and night, as their pilots practised for their big day. Shortly before D-Day the group moved to Fulbeck in Lincolnshire, so having trained there, no aircraft actually took part in the initial phase of the invasion from Weston Zoyland.

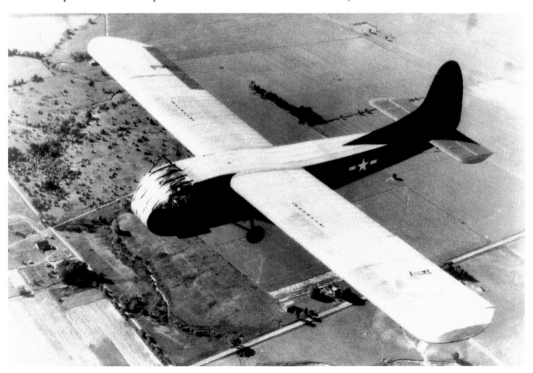

Resupply Missions from Somerset

On 12 June 1944 the Skytrains returned to Weston Zoyland with further gliders, and from then until mid-July they would drop reinforcement troops like those seen above, haul freight to the continent in support of the invasion, and evacuate battle casualties to hospitals in the West Country such as Musgrove Park in Taunton. With the departure of the Americans in October 1944, the station reverted to its role of supporting the gunnery ranges at Doniford. Today the remains of several buildings still dot the landscape (below), providing a poignant reminder of what took place here all those years ago.

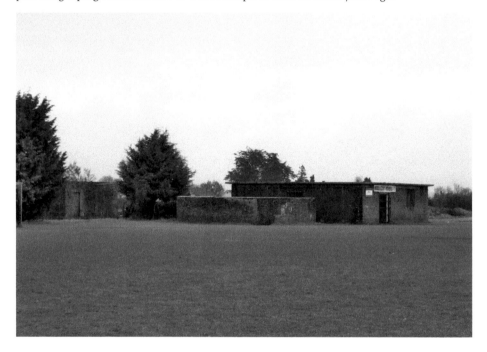

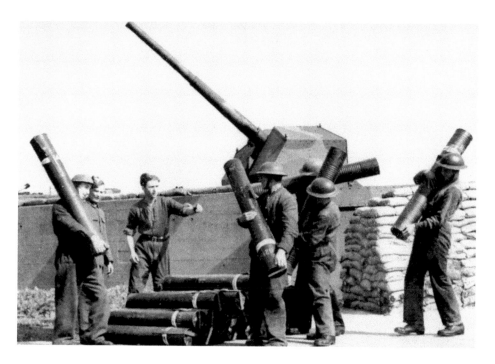

Anti-Aircraft gunnery camp at Doniford

The holiday park seen below now occupies the site that was once the anti-aircraft gunnery camp at Doniford on the shoreline of Bridgwater Bay. Throughout the war thousands of gunners honed their skills here, training with the 4.5-inch anti-aircraft gun (above). This was an adaptation of the 4.5-inch naval gun, which was often placed around maritime bases and used in a dual anti-aircraft and coastal defence role. In this way ammunition and other supplies were always available.

Queen Bee

As well as working closely with aircraft from Weston Zoyland, a small grass airstrip was laid out near the camp at Doniford itself, from where a radio-controlled variant of the Tiger Moth, known as the Queen Bee, was also used for target practice. Launched from the catapult pictured above, the Queen Bee gave the gunners a more realistic idea of how enemy aircraft might react under fire. When occasionally put out of action by shells passing too close, it was recovered from the sea by a War Department tug kept in Watchet Harbour (below).

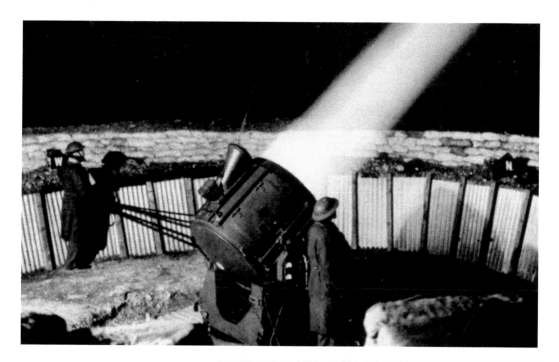

Demonstration on the Ranges

To help the students with night firing at Doniford, a number of searchlights were set up, such as the example above. Aircraft would be caught in the criss-cross of their beams as they towed their targets over the sea. Anti-aircraft gunners played an important role during the Battle of Britain and, in July 1939, General Sir Frederick Pile, who would lead AA Command during that critical summer, enjoyed a demonstration on the ranges. A few months later the batteries of Somerset, such as the one we saw at Sheepway, would be in action for real. To the right is a photograph of a pre-war demonstration at Doniford.

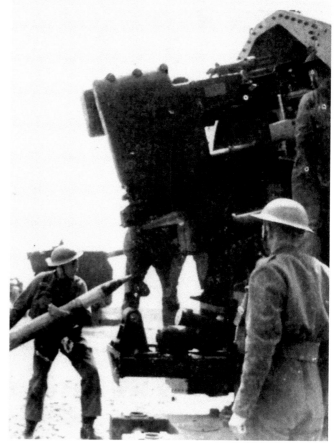

Tank Training on North Hill

At Doniford, practice shells from the ranges fell harmlessly into the sea. It was a similar situation further along the coast on North Hill near Minehead, which in 1942 became a gunnery range for tank crews. Thousands of British, Commonwealth and American troops (above) would benefit from these facilities, which included targets mounted on a railway track. Today there is still much evidence of what took place here through the remains of roads, concrete ramps, and the foundations of the many buildings that made up the military camp as seen below.

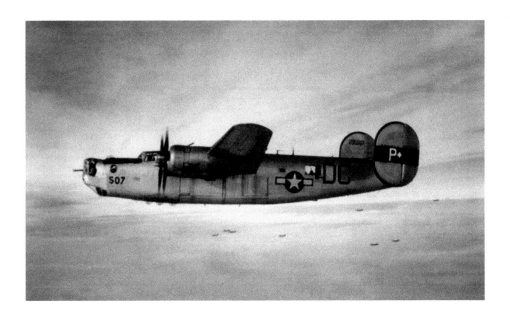

Tragedy at Porlock Bay

Of all the people who visited the North Hill area during the war, perhaps the luckiest was the rear gunner of an American B-24 Liberator (above). In October 1942, poor visibility contributed when his aircraft struck the top of Bossington Hill, leaving the gun turret and its occupant detached but safely resting on the ground. He was lucky because the stricken bomber subsequently crashed on the beach at Porlock Bay. The remaining eleven crew members were killed and today a monument stands near the spot of the tragedy (below). This was just one of many aircraft that met their ends along this windswept shore.

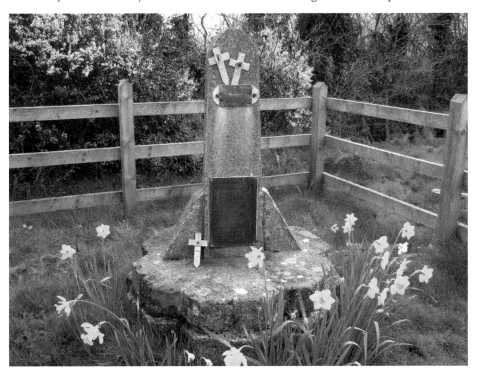

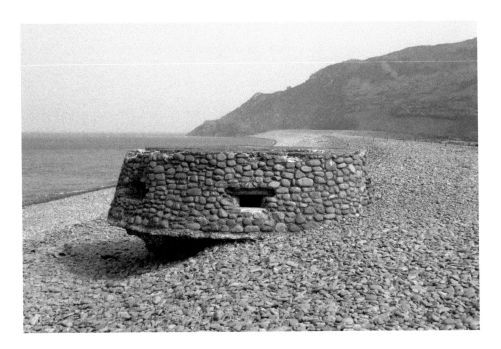

Disguised Pillboxes

Although the western part of the Somerset coast is more rugged than the northern stretch and boasts some of the highest sea cliffs in England, it still had a number of beaches along which Admiral Dreyer considered enemy troops could be landed in the event of an invasion. To guard against this they were also protected by pillboxes, examples of which at Bossington near Porlock are faced with pebbles in order to merge them into their surroundings (above and below). In other places these bunkers were made to blend into their backgrounds using a variety of clever disguises.

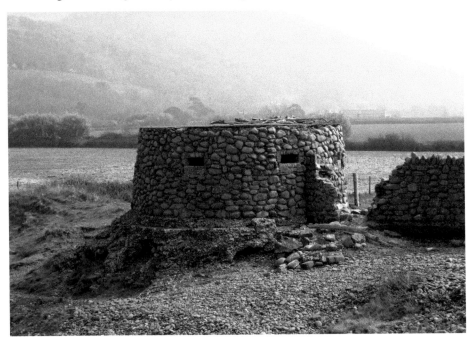

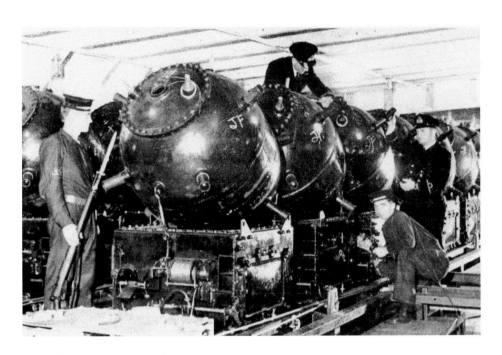

Protecting the Somerset Shore

Other defences on this part of the coast included two 4-inch guns at Minehead. In 1940 Minehead pier was demolished as it stood in the line of fire of these guns. Sadly, however, after test-firing the weapons they were deemed too damaging to the stability of the harbour, so they were never used again. Another gun was mounted near the harbour at Watchet. Also at Watchet, a Second World War mine (below), now used as a collection box for the Shipwrecked Mariners' Society, is a reminder of the dangers that once lurked within the Channel itself, for both enemy and allied shipping. Above similar mines are being laid in the Channel.

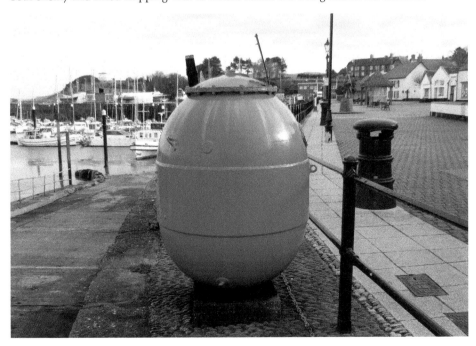

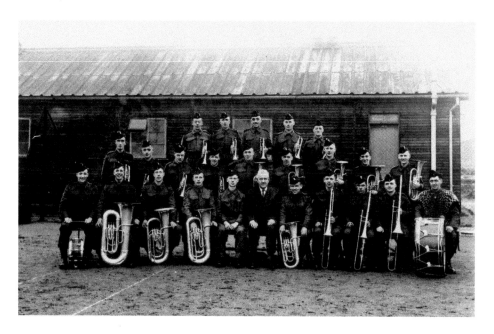

Somerset Light Infantry

For the next stage of our journey we have headed back inland to the county town of Taunton, which has been an important focal point for soldiers from Somerset for hundreds of years; thousands trained here during the war, at either the regimental depot of the Somerset Light Infantry at Jellalabad Barracks, or at nearby Sherford Camp. Ten battalions of the SLI were raised which served in theatres across the globe from Burma to north-west Europe. Above we see the wartime band of the 6th battalion SLI and below Jellalabad Barracks today.

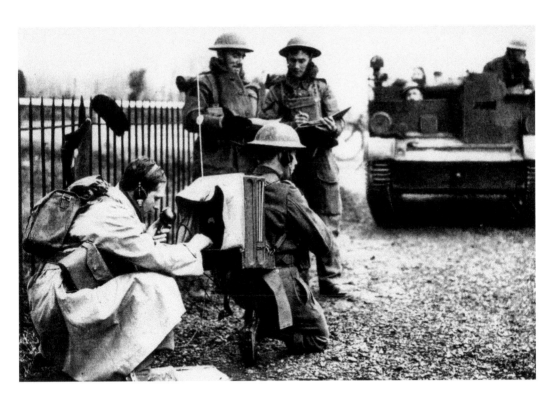

8th Corps Defends the West Country

In 1940 the responsibility for the defence of the counties of Somerset, Devon and Cornwall was given to Lieutenant-General Sir Harold Franklyn. All of the soldiers under his command were collectively known as 8th Corps. Their responsibility was to co-ordinate the defence of the South West against the expected invasion. Their headquarters were at Pyrland Hall, a large house north of Taunton, which is today part of King's College. Above we see 8th Corps troops exercising somewhere in the South West and below a view of The Parade and North Street in Taunton during the 1930s.

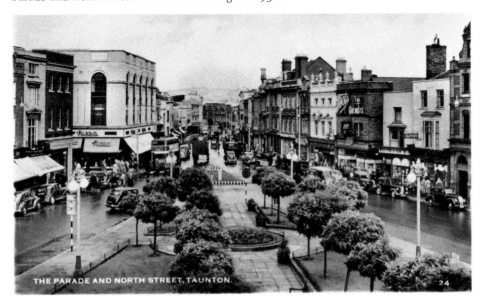

THE PARADE AND NORTH STREET, TAUNTON.

The Home Guard

In 1943, when South West District Command took over the defence of Somerset, most British troops in the county moved out to make way for the Americans. This meant that most of the men left to defend the county under the Command's control were members of the Home Guard. In October 1940, the Home Guard in Somerset (previously the LDV) was split into two groups. The North Group, later known as North Somerset Sector, consisted of seven battalions, while the South Somerset Sector had six. Above are members of No. 3 Platoon Bridgwater Home Guard and below a local unit exercises with an Army Co-operation Lysander from Weston Zoyland airfield.

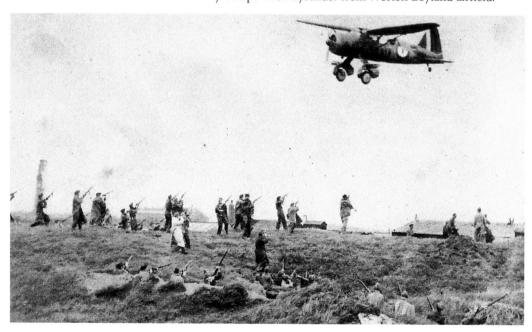

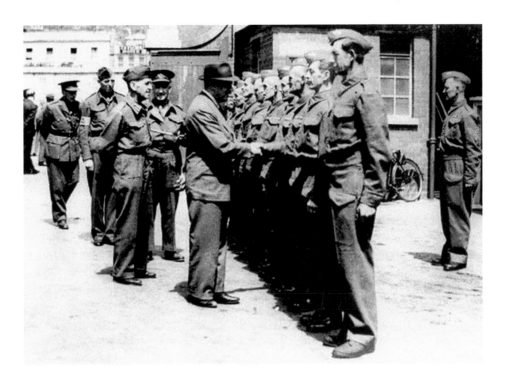

Special Platoons

As well as battalions based along territorial lines, large organisations and companies fielded their own Home Guard units. For instance, the photograph above shows the Weston-super-Mare Post Office platoon outside the old post office, which was situated in what is now The Sovereign Centre. Below is a postcard of Weston's Central Parade in the 1930s, a shoreline these men would have defended against invasion. Similarly, the Glastonbury Invasion Committee War Book noted that the town had seventy-five Home Guard personnel but there was also a Railway Unit thirty-seven strong.

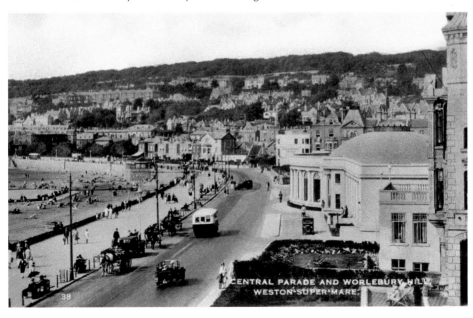

Operation *Bolero*

After the Americans entered the war the whole of the West Country was given over for their use. Tens of thousands of soldiers belonging to the United States First Army would be accommodated in camps all over Somerset, or were billeted in the homes of local people. These photographs show First Army troops based around Yeovil, the example above taken near Nine Springs Park. From here they would be able to train in wild places like Exmoor and the Mendips, while at the same time be close to the ports along the South Coast from where they would eventually set off for the D-Day beaches. This build-up of forces before the invasion was called 'Operation *Bolero*'.

Hardening Up

Some American units did their final training for the invasion on top of the Mendips, which included caving near Charterhouse into GB cave, one of the more difficult descents at the time. Below is a modern photograph of GB Gruffy Reserve. Most had never been caving before but treated the experience as part of their hardening-up process. Rodney Pearce, their local instructor, seen right, even recalled an Apache Indian going down in moccasins. During one trip, a particularly large soldier got stuck in a narrow passage and began to panic. In the end Rodney Pearce applied an acetylene lamp to his backside, after which he slid through quite easily.

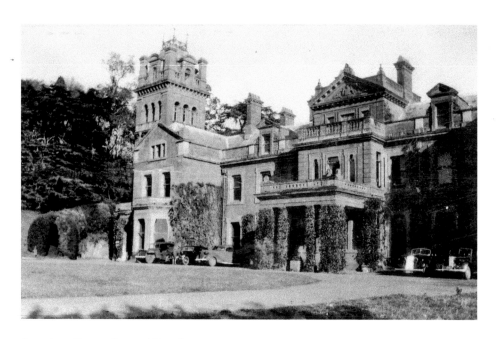

American Forces Around Taunton

Around Taunton, Hestercombe House (above) became the District Headquarters of US Services of Supply, who were responsible for the accommodation of troops and supplying them with everything they needed from equipment to food and drink. Norton Manor Camp at Norton Fitzwarren became the HQ of the US 5th Corps. Also at Norton Fitzwarren, the Americans took over and enlarged a huge military stores depot which became known as G50. The surviving Nissen huts below were also later used to house prisoners of war. The Americans also built hospitals for their soldiers including the 67th General Hospital at Musgrove Park, which remains the town's main medical centre.

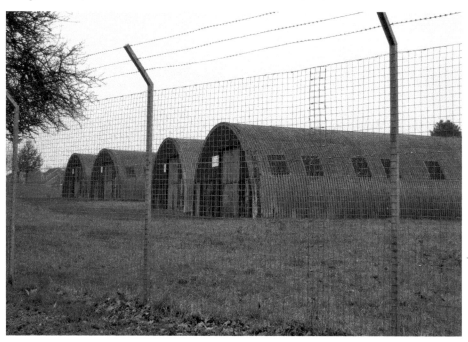

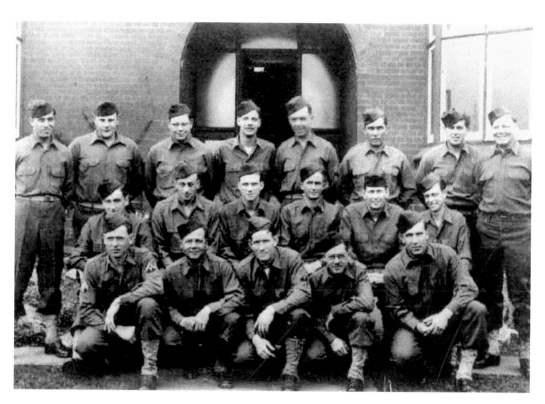

Lasting Friendships

The GIs were friendly and generous and liked nothing more than visiting locals in their homes, often bringing foodstuffs that were rationed. Carole Miller was only a baby during the war, but her parents often told her about their American friend from Milwaukee, Al Johnson, who would visit their home in Alfred Street, near Victoria Park where he was billeted. After returning home the family received many letters from Al in appreciation of their friendship. One day when she was six, there was a parcel waiting on her return from school: inside was a beautiful doll (right). Above, GIs outside a Taunton house.

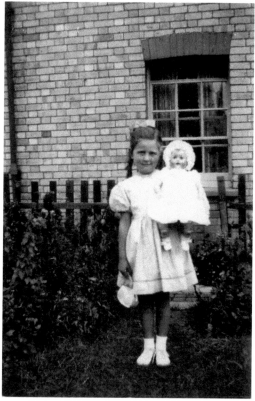

GI Brides

In 1941, Sandhill Park at Bishops Lydeard was leased to the Americans as the 185th Hospital and it was here that Peggy Holbrow (left) fell in love with her GI, Kenneth Chapman, who was being treated there. Ken asked Peggy to marry him but she declined and often wondered whether she did the right thing. Many girls from Somerset did marry their American sweethearts. After the war the US Army mounted Operation *War Bride*, which from 1946 onwards would eventually transport, free of charge, more than 70,000 women and children to a new life in the United States. Below, English girls often met their future husbands at dances held at American hospitals and bases.

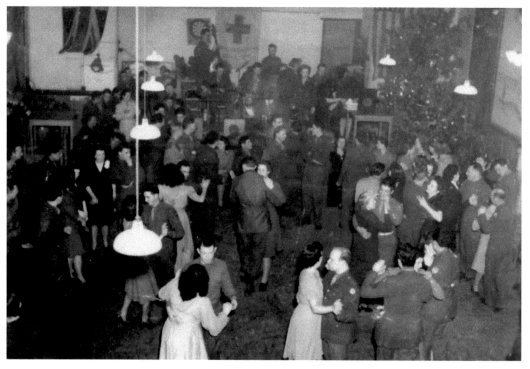

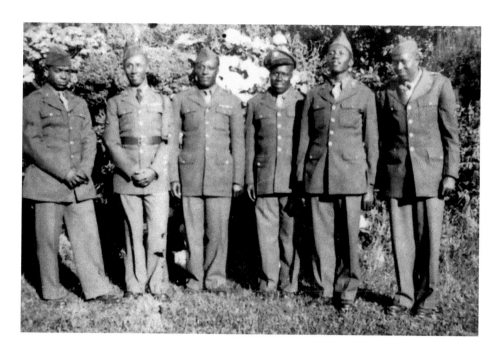

Black Americans

The following extract comes from the Norton Fitzwarren Parish Council Minutes, dated 2 October 1944: 'Italian Prisoners of War and Coloured Troops – After a discussion on the dangers of mixed troops being at liberty to roam our streets and fields at will, resolved to wait a while to see what action can be taken by the military, and in the hope that their stay will not be of long duration.' From this extract it seems the people of Norton Fitzwarren gave Black GIs the same respect as enemy prisoners. Thankfully not everyone felt the same and many people welcomed African Americans like those pictured above into their homes. Many of these soldiers worked at the G50 stores pictured below.

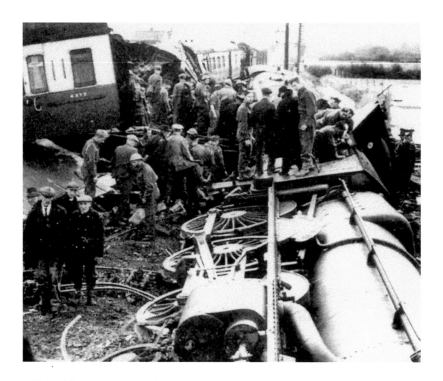

Rail Accident at Norton Fitzwarren

One of the worst rail accidents of the entire war happened at Norton Fitzwarren in the early hours of 4 November 1940. The 9.50 p.m. Express from Paddington had just left Taunton station when the driver misread the signals and slipped onto a relief line, consequently derailing. Twenty-seven people were killed and fifty-six seriously injured. Although this incident had nothing to do with the war as such, the blackout certainly hindered the efforts of the rescue parties. Above is a contemporary photograph of the aftermath of the accident, while below we see the scene today.

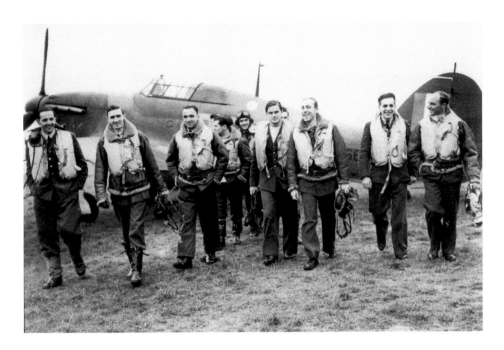

RAF Culmhead

Although the RAF didn't have any fighter airfields in the county at the time of the Battle of Britain, this situation was rectified with the opening of RAF Charmy Down near Bath in November 1940, and RAF Culmhead near Taunton in August 1941. At 894 feet above sea level in the Blackdown Hills, the latter was the second highest airfield in the country. Originally it was called RAF Churchstanton after the local village, but was later renamed to avoid confusion with RAF Church Fenton in Yorkshire. Above, Polish Hurricane pilots are pictured at the airfield, and below, a building at the site photographed in the 1990s.

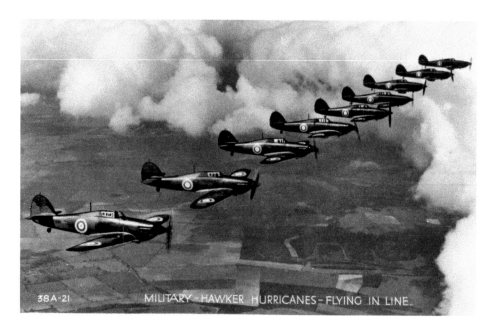

No. 2 Polish Fighter Wing

Culmhead began life as an emergency landing ground and dispersal airfield, but it was also the home base of some of the aircraft mentioned earlier which took part in the barrage balloon cable cutting trials on the Pawlett Hams. As a fighter station it was first occupied by No. 2 Polish Fighter Wing, equipped with Hawker Hurricanes, and later by Czechoslovakian units flying similar aircraft. Their primary tasks were to provide fighter escorts for bombers crossing the English Channel, as well as the air defence of Exeter and Bristol. Above, a squadron of Hurricanes and below the remains of another wartime building at the airfield today.

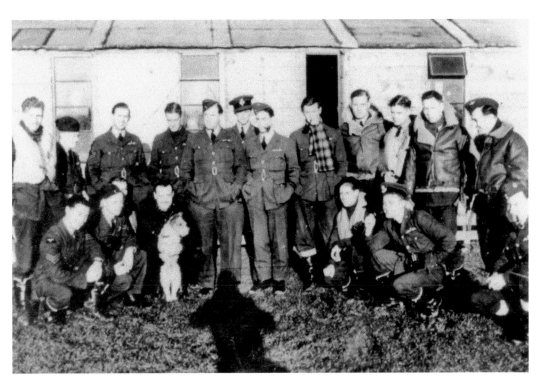

Taking the Fight to the Enemy
Many British units also flew from
Culmhead, including Nos 66 and 504
Squadrons equipped with Spitfire
Vs, and Nos 894 and 897 Naval Air
Squadrons flying Typhoons. Some
of these units undertook what were
known as Rhubarb attacks over
France, causing mayhem to German
communications and transport
systems. On D-Day No. 131 Squadron
flew their Spitfire VIIs from Culmhead
on the very first fighter sweep
over Normandy, attacking railway
locomotives and convoys of military
vehicles. They were followed later in
the day by 616 Squadron (above) on
a comparable offensive. Below we see
inside one of the remaining buildings
at the airfield.

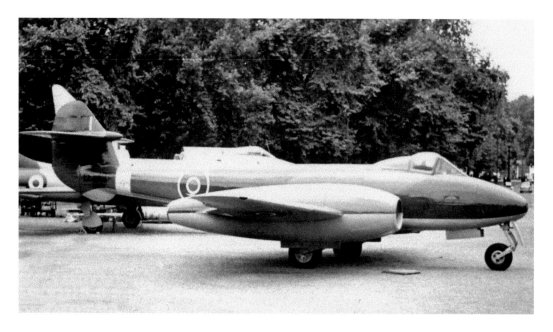

Entering the Jet Age

Because of Culmhead's remote location, in July 1944 it was the scene of an event of enormous historical importance: the delivery of the very first two jet-powered aircraft to enter service with any allied air force. They were Gloster Meteor Mk Is, which were to be tested by members of 616 Squadron. Above is a slightly later Meteor F4. The Air Ministry considered Culmhead suitable for this task because its isolation in the Blackdown Hills would allow a degree of secrecy. Somerset therefore holds a unique place in the story of jet-powered flight. Some of the site is now occupied by a business park and below we see what would have been the entrance to the airfield.

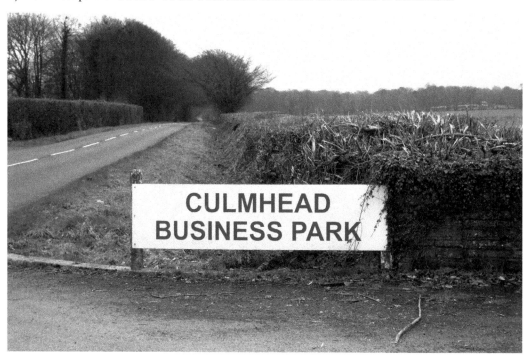

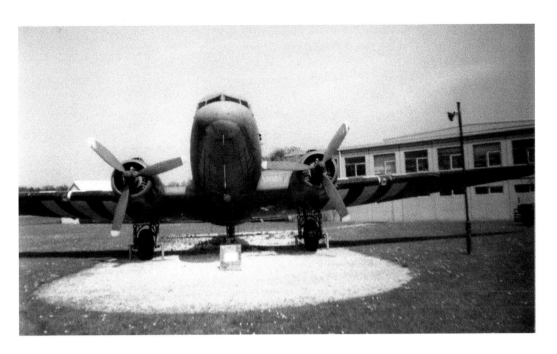

Dakotas at Merryfield

Earlier we saw how, during the build-up to the invasion, the 442nd Troop Carrier Group of the United States Army Air Force moved into the airfield at Weston Zoyland. At the same time, the 441st Troop Carrier Group occupied Merryfield aerodrome near Ilton (below) with their own air armada of Douglas Dakota Skytrains (above) and Waco gliders. The airfield itself was still under construction, but again, similar to Weston Zoyland, training soon got under way as the Skytrain pilots towed the gliders around the Vale of Taunton both day and night simulating an airborne assault.

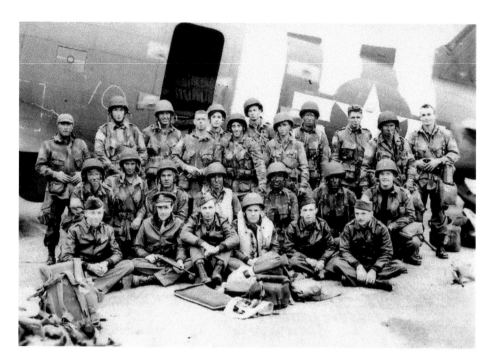

D-Day from Merryfield

Unlike Weston Zoyland, on D-Day the runways of Merryfield were a hive of activity. Aircraft from here would carry elite pathfinders of the 82nd and 101st US Airborne Divisions (above) to their designated dropping zones near the town of Sainte-Mère-Église. Shortly after midnight on 6 June, Skytrains with Waco gliders in tow took off from Merryfield carrying men of the 501st Parachute Infantry Regiment to Normandy. At around 1.30 a.m. they began to disgorge the first pathfinders over their drop zones. Some of the original airfield buildings were still being used as a village school when the photograph below was taken in the 1980s. They have since been demolished.

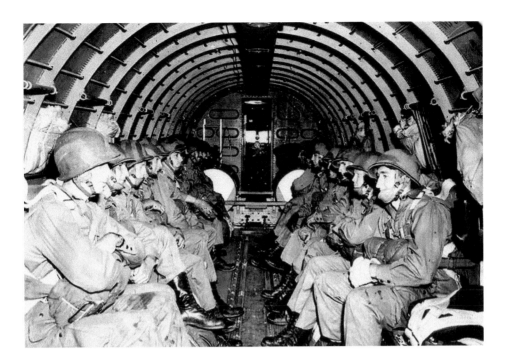

Medical Reception Area

On D-Day more than 1,400 men would be lifted out of Merryfield (above). On 7 June, another fifty Skytrain and glider combinations took off from the airfield shortly after seven o'clock in the morning, this time carrying further troops, equipment and ammunition. Back at Merryfield a medical reception area was established ready to receive and process wounded soldiers. A fleet of ambulances (below) waited to take the more seriously injured to Musgrove Park or other American hospitals in the area and over the next few weeks the roads between the aerodrome and these became increasingly busy.

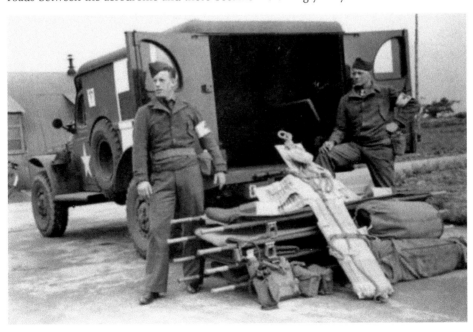

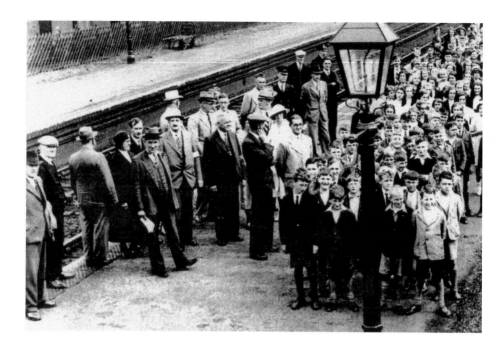

Evacuees

Because of its predominantly rural aspect, the county of Somerset was one of the prime locations to which evacuees were sent at the beginning of the war. The initial exodus from London in September 1939 was codenamed Operation *Pied Piper*, when children from areas considered at risk from bombing arrived at train stations all over the West Country (above), to be billeted with local families. At the village of Donyatt between Chard and Ilminster, the statue below of Doreen an evacuee girl is now a permanent memorial to the three million people who took part in the scheme.

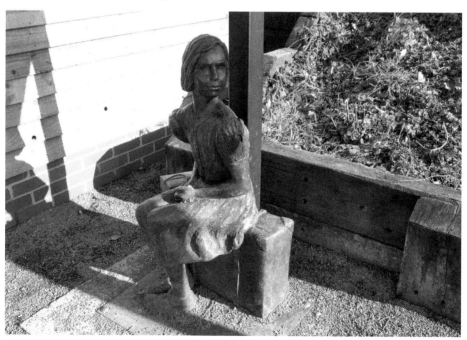

Escaping the Bombs

The photograph above was taken in the grounds of the old Vicarage in Wembdon near Bridgwater in August 1940 and shows evacuated pupils of Hungerford Road School, north London. Classes were held in the old vicarage as shown in the picture below. In some instances, entire schools moved together, while in other situations children were evacuated individually. In many cases these youngsters spent the whole of the war away from their home and families living in Somerset and other rural counties, an experience which would have a profound and lasting effect on each of them.

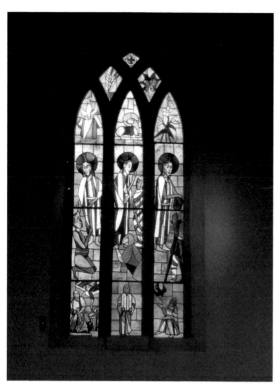

Prisoners of War

A number of places are reminded of their wartime past by memorials; such is the case at the church of St Mary the Virgin at East Chinnock between Crewkerne and Yeovil (below). Here you will find a series of stained-glass windows (left) installed in the 1960s by Gunther Anton, a Luftwaffe airman shot down over England. After the war he inherited a stained glass factory in Germany and he crafted the windows in appreciation for the friendship he was shown by local parishioners while he was a prisoner at Houndstone POW camp in Yeovil and working on a local farm.

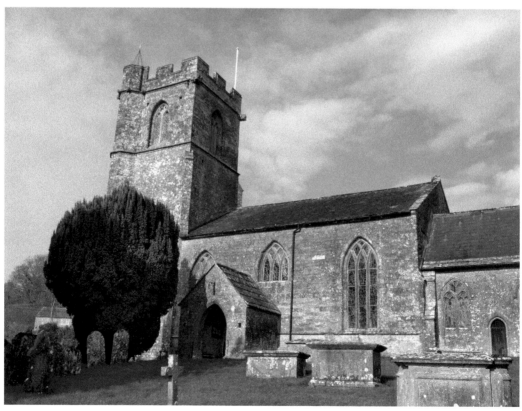

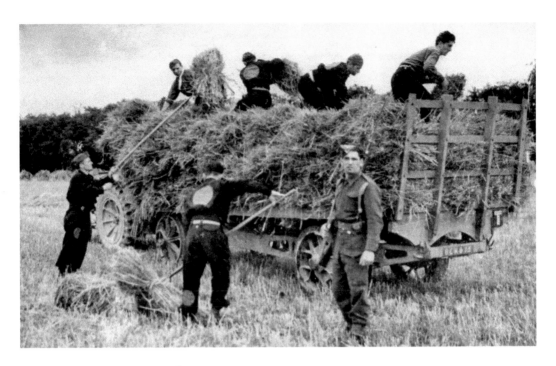

Helping Out on the Land

Somerset, similar to many other counties, had numerous POW camps housing both German and Italian internees. It was quite common for some of these prisoners to earn their keep by working, and with Somerset being a largely rural county, this often involved labouring in the fields, normally under close guard by local troops. But as the war drew to its conclusion, this situation became ever more relaxed. These pictures show POWs working on farms somewhere in the West Country.

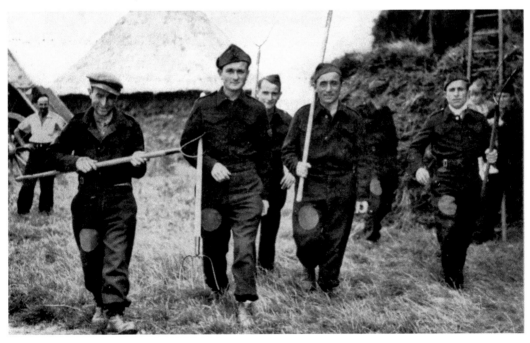

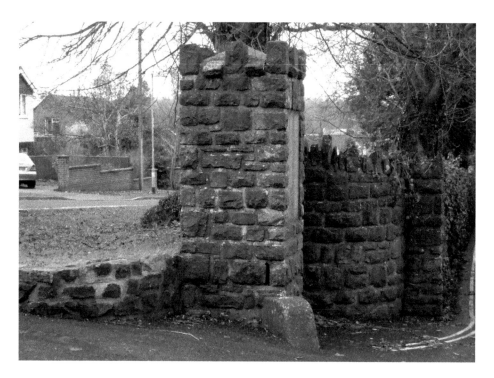

POW Camps Around Wells

Around the city of Wells there was a cluster of camps, and the discerning eye can still see their evidence. The area now occupied by Thales was formerly the site of Penleigh Camp. In College Road a pair of stone pillars (above) was originally the gateway to Stoberry Park POW camp, and drivers on the A39 can't fail to notice the statue of Romulus and Remus (below) which was sculpted by Gaetano Celestra, an Italian prisoner said to be in gratitude for the kindness he received from local people.

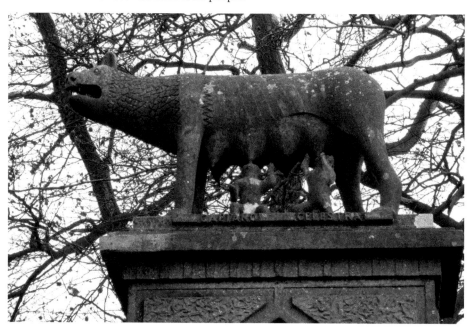

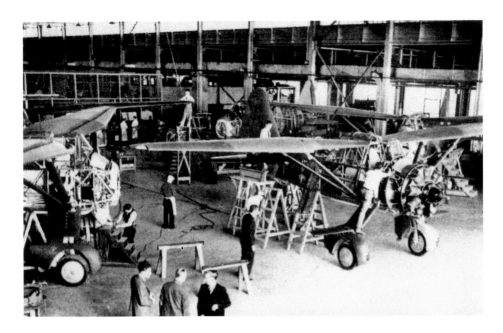

Building Lysanders in Yeovil

The town of Yeovil is another of Somerset's main commercial centres, which has been building aeroplanes – and later helicopters – at its Westland Aircraft factory, now Augusta Westland, since 1915. By the start of the Second World War it was producing the Westland Lysander, which in 1936 was intended to be a modern general purpose aircraft. The Lysander had remarkably short take-off and landing capabilities, making it suitable for working alongside the army in the field, providing services such as reconnaissance, air photography, and artillery spotting. Above and below Lysanders are seen on the Yeovil factory floor.

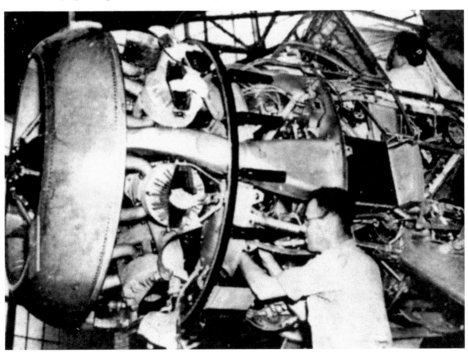

A Multi-Purpose Aircraft

The Westland Lysander (below) could even carry a small bomb load as seen above. In 1939, many went to France, where they suffered so badly against the Luftwaffe that they were taken out of front-line duties. For the rest of the war they provided target-towing and search-and-rescue roles. Later, they found a niche ferrying agents of the SOE into occupied France during the stealth of night. The company was also building a powerful long-range twin-engine fighter called the Whirlwind, which was armed with four 20mm cannons, offering firepower well in advance of contemporary thinking.

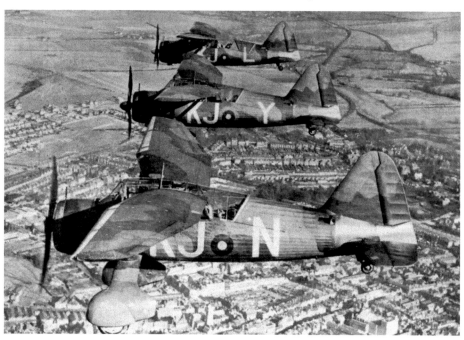

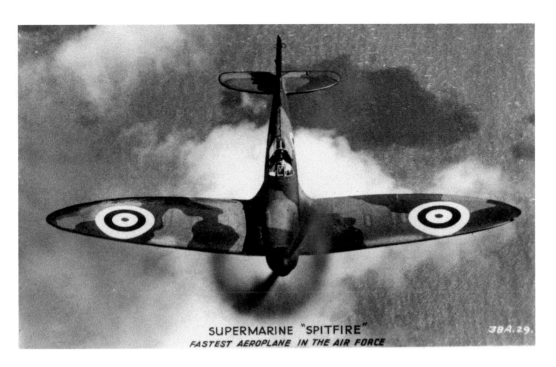

SUPERMARINE "SPITFIRE"
FASTEST AEROPLANE IN THE AIR FORCE

Building Spitfires in Yeovil

The destruction of the Supermarine factories at Southampton by German bombing in September 1940 brought Spitfire production there to a standstill, and Westland was one of the factories selected to recover this situation. Within three months Spitfires (above) were rolling off the production line supported by a network of shadow factories hastily set up in the Yeovil area. Westland also played a major part in the design of the naval version of the Spitfire, known as the Seafire (below). By the end of the war over 2,000 Spitfires and Seafires had been built in the Westland factories.

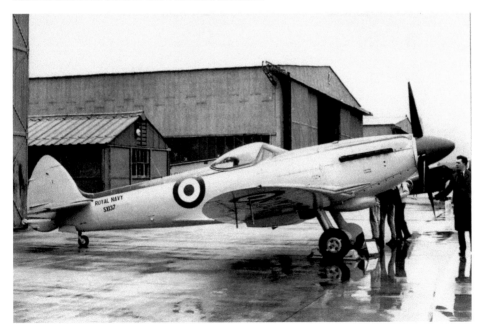

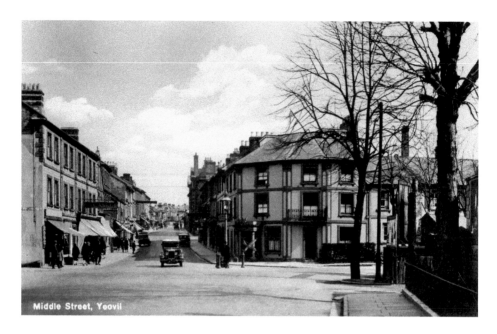

Middle Street, Yeovil

Aircraft Innovation

One of the most important aircraft produced during the war was the Welkin high-altitude fighter. It was needed to combat high-flying German reconnaissance aircraft. The requirement to operate at altitudes of 40,000 feet or more called for cabin pressurisation and it was from this pioneering work that the independent company Normalair developed. The Westland Aircraft factory (below) and its airfield therefore made Yeovil another potential target for German bombs. The first attack took place on 15 July 1940 when Junkers Ju88s dropped twelve bombs on the airfield, but luckily nobody was killed. The postcard above postmarked 1942 shows how Middle Street, Yeovil, would have looked in the early war years.

Bombs Hit Sherborne by Mistake

The Westland factory was the target again on the afternoon of 30 September, when around forty Heinkel He IIIs (above) took part. Hindered by fog, they went off course, dropping their bombs on the nearby town of Sherborne in Dorset by mistake, seen below in a pre-war postcard. Ten people were killed. There were several more attacks on Westland's but in most cases the damage caused to the factory was minimal as the bombs landed in nearby housing estates. The worst attack was on 7 October 1940, when fifteen people were killed. Many more would die in the coming months.

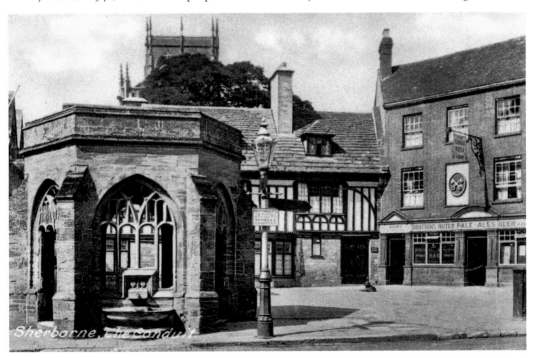

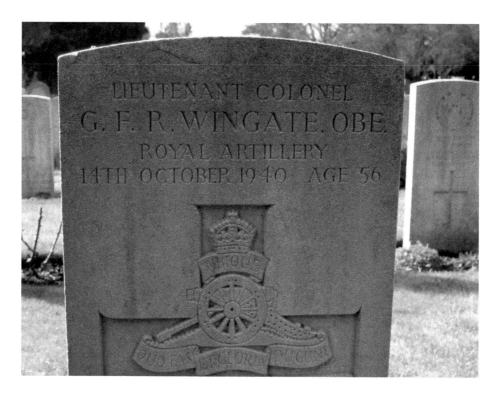

Army Camps at Houndstone and Lufton

In October 1940 five people were killed when Houndstone army camp in Yeovil was targeted, while during an attack on nearby Lufton camp, thirteen soldiers were left dead, including the commanding officer of 208 Anti-Aircraft Regiment, Lt-Col G. Wingate, cousin of the legendary Major-General Orde Wingate. Today there is little evidence of either of Yeovil's army camps other than the buildings seen below. Their sites are now occupied by business parks. Graves of soldiers killed at these camps, including Wingate's pictured above, can be found in the town cemetery.

Barwick House, near Yeovil

GIs in Yeovil

In 1942 the British garrisons moved out of the army camps in Yeovil to make way for the Americans. There was another camp in the grounds of Barwick House, seen above, but by the time of the invasion, the number of troops in the area had outgrown these facilities and GIs were being housed in schools, church halls, shops and other public buildings, as well as in the homes of local people. In the High Street close to the war memorial, a special monument erected in 2004 is dedicated to the 12,000 American troops who passed through the town (below).

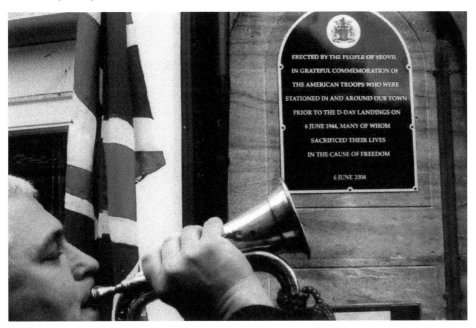

ERECTED BY THE PEOPLE OF YEOVIL
IN GRATEFUL COMMEMORATION OF
THE AMERICAN TROOPS WHO WERE
STATIONED IN AND AROUND OUR TOWN
PRIOR TO THE D-DAY LANDINGS ON
6 JUNE 1944, MANY OF WHOM
SACRIFICED THEIR LIVES
IN THE CAUSE OF FREEDOM

6 JUNE 2004

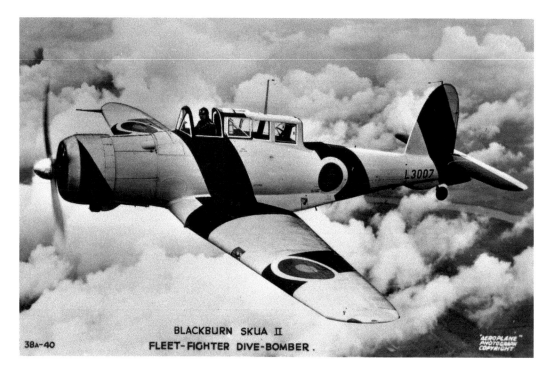

BLACKBURN SKUA II
FLEET-FIGHTER DIVE-BOMBER.

38A-40

RNAS Yeovilton

Somerset's largest military establishment today is the Royal Naval Air Station at Yeovilton near Ilchester, which was commissioned on 1 June 1940 as HMS *Heron*. It was here that, among other things, the Fleet Air Arm established its Naval Air Fighting School, an inland training base for fighter pilots, many of whom would operate their aeroplanes from the decks of aircraft carriers. During the war years nearly every type of aircraft flown by the Royal Navy would have been seen here, including Blackburn Skuas (above), and Blackburn Rocs (below).

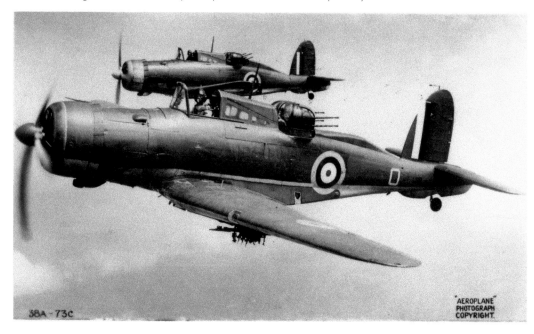

38A-73C

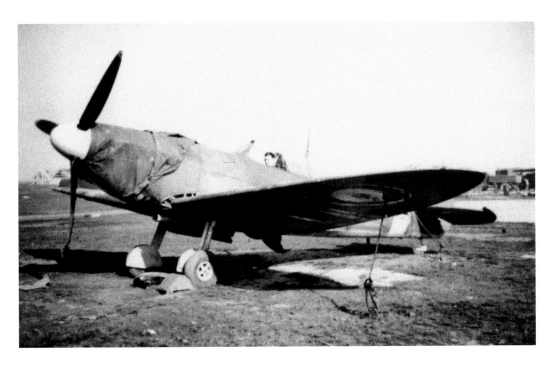

Satellite Stations

Also based at several hangars on the airfield was a shadow works of the Westland Aircraft Factory, which became a major repair centre for damaged Spitfires (above). So many aircraft and pilots used the air station that it was necessary to build satellites at nearby Charlton Horethorne and Henstridge to alleviate some of the pressure. Today RNAS Yeovilton is still the busiest military base in Somerset. It is also the home of the world famous Fleet Air Arm Museum. You can still see various old hangars at Yeovilton around the station perimeter (below).

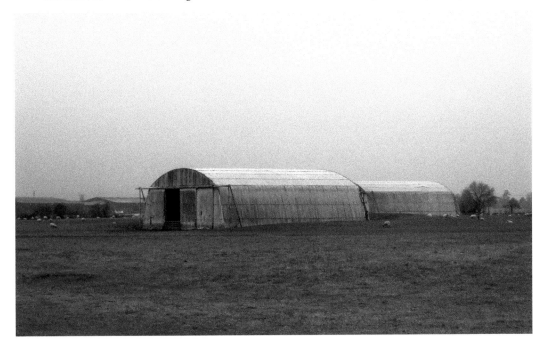

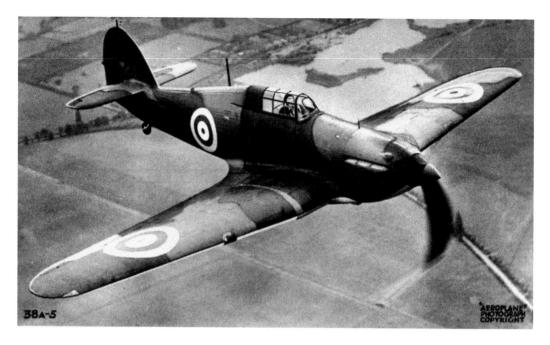

Tragedy at Downside Abbey

Yeovilton was bombed four times but there were no fatalities. There were, however, a number of training accidents which resulted in loss of life, by far the worst of which occurred on 15 May 1943, when two pilots from the base flying Hurricanes (above) were practising in the area near Downside Abbey School at Stratton-on-the-Fosse. The instructor was in front with his pupil, Sub-Lieutenant Alan Cairnhill McCraken, a young trainee pilot from New Zealand following close behind. In the photograph below, Downside Abbey can be seen behind the cricket pitch and pavilion where the tragedy in question occurred.

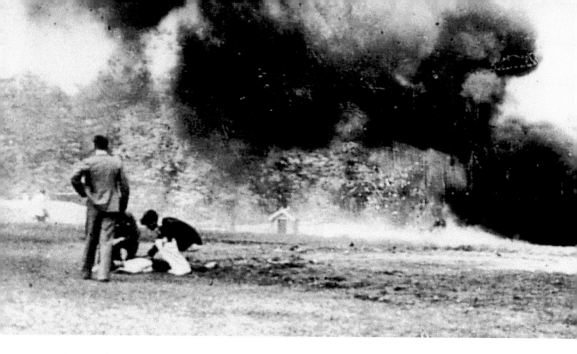

Taken at the Scene

A cricket match was taking place when the two aircraft, having circled the school several times, approached some trees. The first plane cleared these but the second clipped the tallest. McCracken lost control of his Hurricane which hit the ground and ploughed into a group of spectators along a bank. Nine boys and the pilot died in the accident, all of which were buried in the monks' cemetery in the shadow of the abbey church. The remarkable picture above was actually taken at the scene of the tragedy, while the picture below was taken during the subsequent funerals.

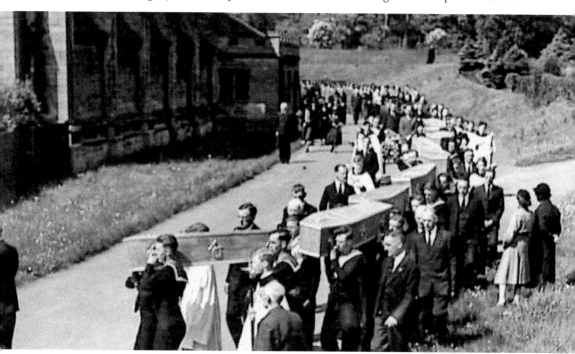

Accident on the Somerset & Dorset Line

Henstridge was the scene of a serious wartime accident that was shrouded in a degree of mystery. At the time there was a tiny station at the village on the Somerset & Dorset Railway line. On 13 March 1944, a train full of GIs heading for the coast was approaching and passing under the narrow rail bridge pictured above on the A30, when an American tank transporter toppled over the side of the bridge, crashing down onto the train beneath. Eyewitnesses reported seeing many casualties but, to my knowledge, the American authorities have never announced the number of those who died. Below is the spot where the accident occurred.

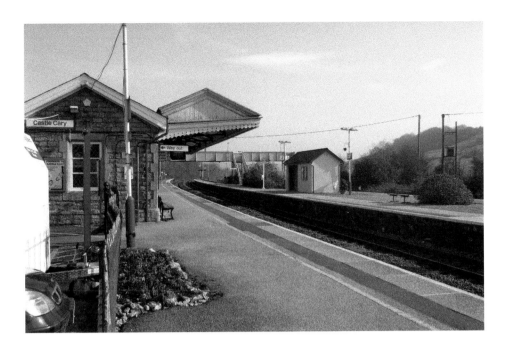

Railways Under Attack

The railway network also suffered through enemy attacks, as the Germans endeavoured to disrupt as much rail traffic as possible. On the morning of 3 September 1942, considerable damage was caused to Castle Cary station (above) and three people were killed when a lone aircraft offloaded four bombs over this busy junction. Two days later it was the turn of Templecombe (below); a similar attack perpetrated by a single bomber coming in low and fast. Five railwaymen and eight rail passengers were killed. But in spite of these attacks, the railway network in the West Country remained crucial to the war effort.

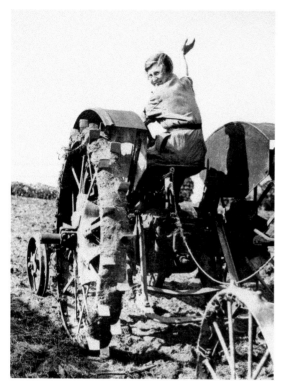

Women's Land Army

As we have already seen, many parts of Somerset aided the industrial side of the war effort but one of its greatest contributions was in agriculture. In June 1939, as the prospect of war became increasingly likely, the government reintroduced the Women's Land Army. The majority of recruits came from the countryside but more than a third lived in London or other industrial cities. By 1944 it had over 80,000 members. At Pilton a memorial in the grounds of the historic tithe barn (below) is now dedicated to the Land Girls of both World Wars. Many Land Girls learnt to drive tractors at Pilton (left).

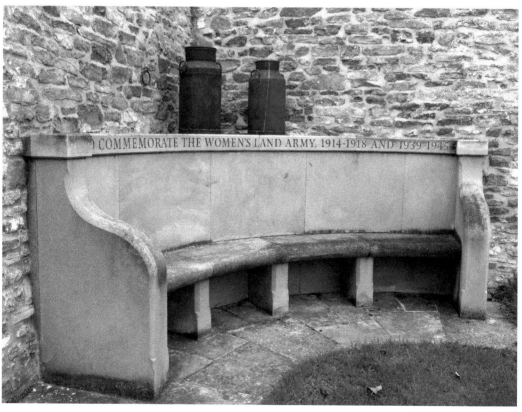

THE END.

Executions at Shepton Mallet

Shepton Mallet has the grim reputation of being where the Americans executed some of their own soldiers during the war. A prison had existed in the town since 1610, making it the oldest in the country. At the start of the war it was originally leased to the British army but in 1942 it was handed over to the Americans who built the hangman's block pictured below. Sixteen Americans were hanged here during the war with another two put to death by firing squad; their crimes normally rape or murder. Above is the trapdoor inside the execution chamber.

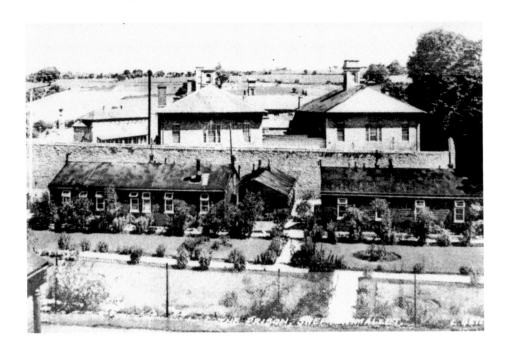

Safekeeping National Treasures

The regime at Shepton Mallet prison (above) was harsh and was said to be the inspiration for the opening passages in the book *The Dirty Dozen* by E. M. Nathanson, later immortalised in the 1967 movie. Part of the prison was also used to secretly house some of the nation's great treasures, including the Domesday Book (below) and a copy of the Magna Carta. It is even rumoured that some of the Crown Jewels were kept here. After the war the prison was handed back to the British army and finally returned to the civilian authorities in 1966.

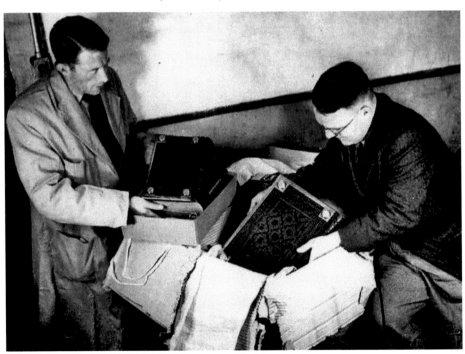

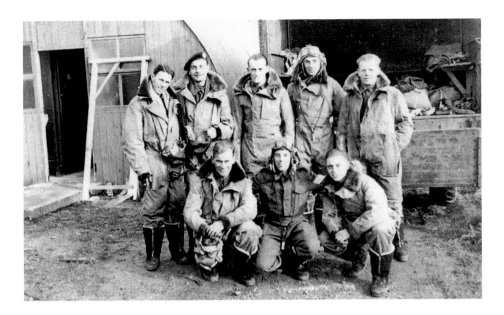

First Casualties of Arnhem

Near Paulton at a place called Double Hills the monument pictured below marks the spot of another tragic event to take place in Somerset. At 10.25 on 17 September 1944 a Stirling towing a Horsa glider took off from RAF Keevil in Wiltshire. It was part of the first airborne lift to Arnhem during Operation *Market Garden*. On board the Horsa were two members of the Glider Pilot Regiment and a unit of Royal Engineers. At 11.05 an explosion occurred within the glider which caused it to break away from the tow aircraft and crash to the ground killing all occupants. Above are members of the Glider Pilot Regiment, including those who died.

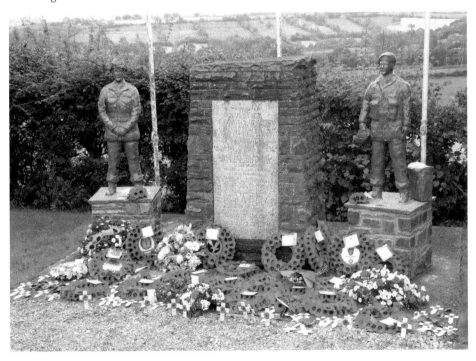

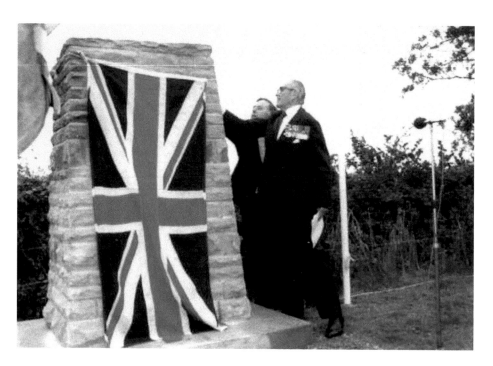

Double Hills Committee

In the 1970s the Double Hills Committee led by Peter Yeates was formed with a view to erecting a memorial on the site of the crash. Their dedicated work came to fruition when, on 23 September 1979, the memorial was unveiled by Major-General Roy Urquhart (above), who had commanded the 1st Airborne Division at Arnhem, and the inaugural memorial service was held. Since that date an annual service (below) has taken place. All twenty-three victims of the Double Hills tragedy were buried with full military honours and now lie interred at the Milton Road cemetery in Weston-super-Mare.

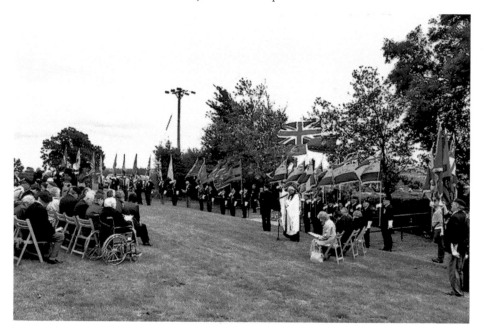

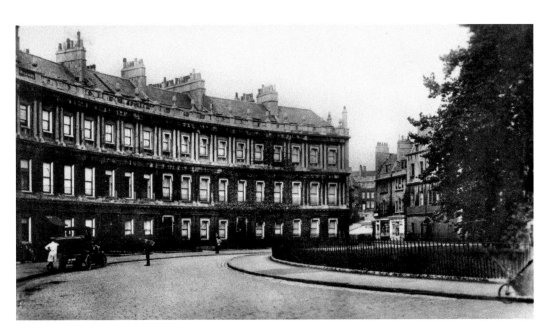

Bath Then and Now

During this book we have seen how the Luftwaffe bombed many parts of Somerset, causing death and destruction, but the place that suffered worst is also where our story ends. Bath is one of the most beautiful and historic cities in the country and it was its very status as a centre of national heritage that caused it to be targeted during a series of raids that became known as the Baedeker Blitz, which also included attacks on Exeter, Canterbury, Norwich and York. Above is a pre-war postcard of The Circus and below the same scene today.

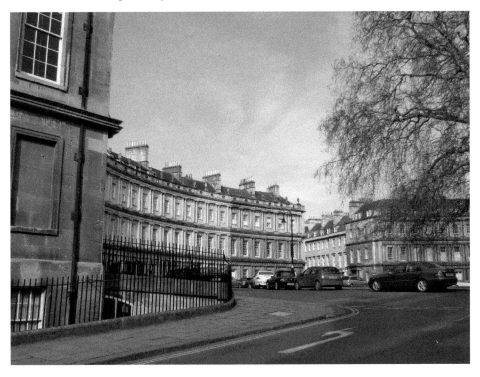

Baedeker's Guide to Britain

Karl Baedeker was a nineteenth-century travel writer who published a series of guides to foreign countries including *Baedeker's Guide to Britain* in which he recommended all of these cities for their architectural importance. In some ways the attacks were similar to those suffered by Weston-super-Mare, as although Bath accommodated a number of military establishments and factories undertaking war work, the raiders seem to have ignored these in favour of targeting the civilian population. Above is another pre-war view of the city and, below, Paulteney Bridge today, one of Bath's most famous landmarks.

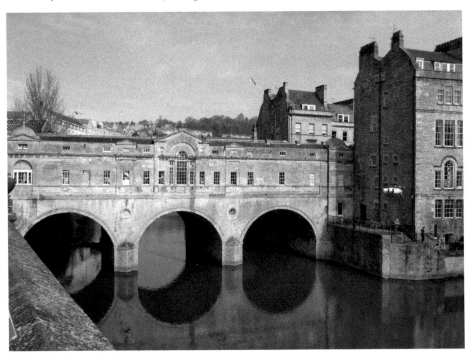

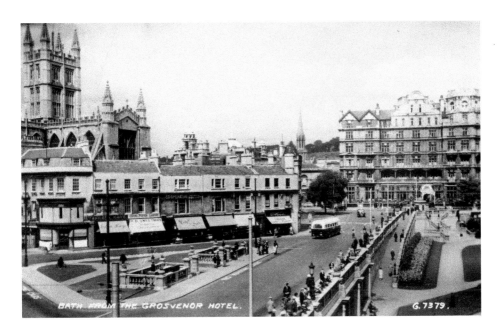

The Admiralty Arrives in Bath

Bath was also an evacuation centre with over 4,000 women and children arriving by train at the onset of hostilities. Even some government departments relocated here, most importantly parts of the Admiralty, which moved its entire Design and Naval Construction Department to the city. At first hotels and other large buildings were requisitioned for its use, until hutted camps were built at Lansdown and Foxhill. Above and below we see contemporary and current views of the Empire Hotel used as part of the Admiralty establishment.

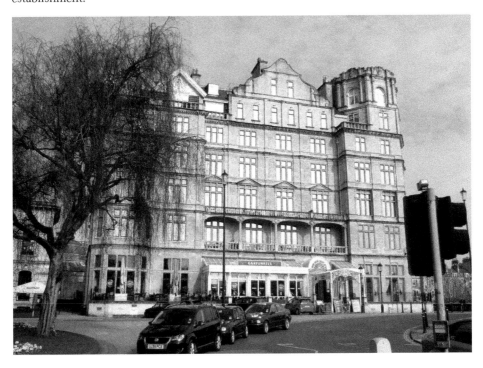

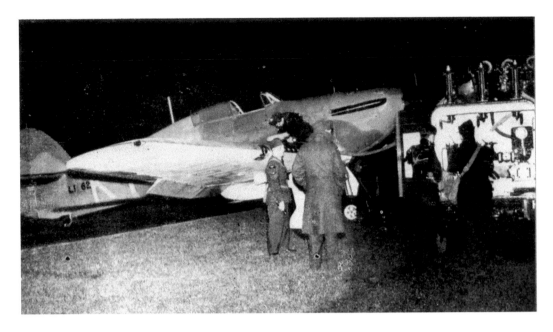

Lack of Protection

Factories around the city, such as Stothert & Pitt and the Horstmann Gear Company, made a variety of things from gun mountings for tanks, to minesweeping gear. Nevertheless, the War Office was so convinced that Bath would not be subjected to any intense bombing that it was left virtually unprotected with no anti-aircraft defences or even a balloon barrage, although from November 1940 the RAF established the fighter airfield at Charmy Down 3 miles to the north. Above we see a Hurricane night fighter at Charmy Down and below the remains of a gun emplacement at the airfield today.

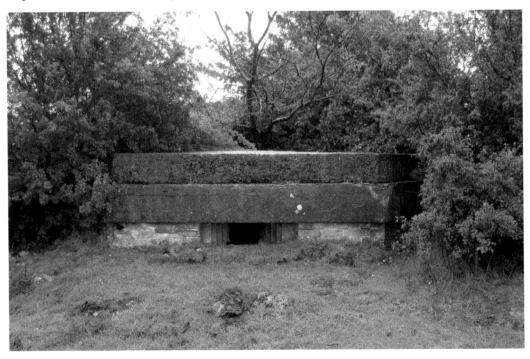

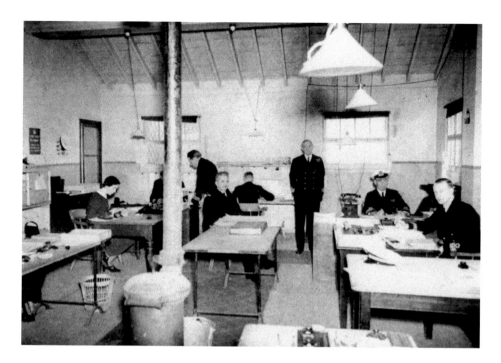

Why Was Bath Attacked?

It is unlikely that the Germans were aware of much of the activity in the city, particularly where the Admiralty was concerned (above). They probably thought the city's hotels, such as The Fernley (below), were simply being used to relocate high-ranking military staff officers. So why then was Bath attacked with such ferocity? The raids were said to be in reprisal for the RAF's bombing of Lubeck and Rostock. Both of these were regarded in Germany as cultural gems, containing numerous ancient and historic buildings. In the case of Lubeck around 40 per cent of the city was devastated.

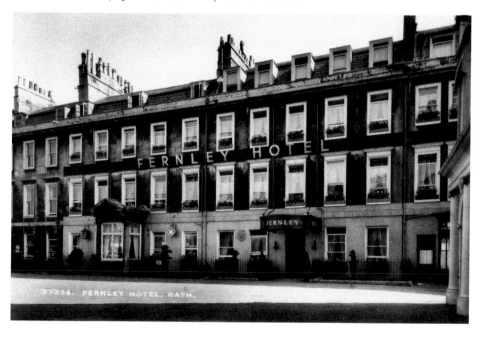

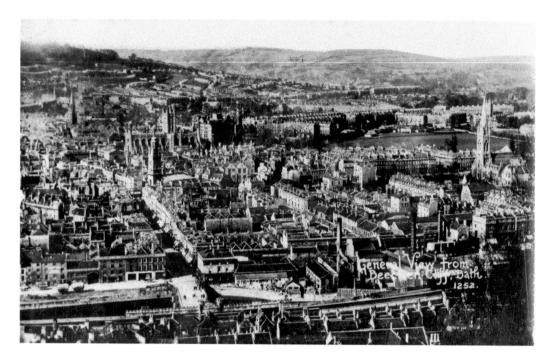

First Attack of the Baedeker Blitz

The British claimed that the Nazis were using Lubeck and Rostock to supply the Russian front but Hitler was infuriated and vowed revenge on English heritage sites. The raids on Bath took the form of three separate attacks, with the first on the night of Saturday 25 April 1942. The air-raid sirens sounded at 22.59 but the people of the city paid little attention, thinking it was just another raid on Bristol. In some places people say that no sirens were heard at all. Above is a pre-war view across the city and below, German bombers en route.

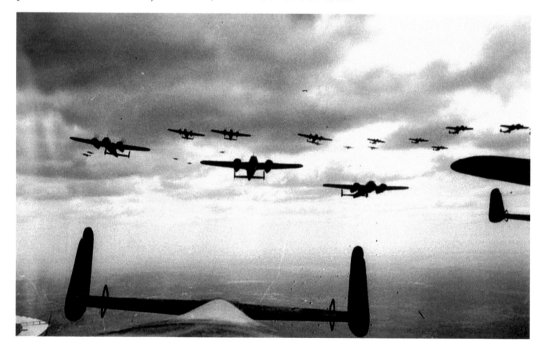

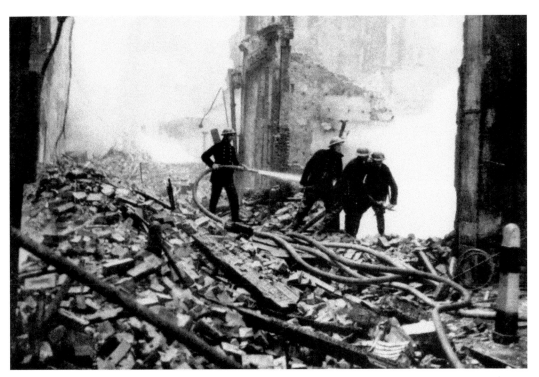

The First Bombs are Dropped

At 23.15 the first aircraft appeared over the city dropping incendiaries. These were designed to create fires and mark the target for the bombers that came behind them to home in on. Wave after wave attacked at very low level in an ordeal that lasted for nearly an hour. Virtually unopposed by both ground fire and defending aircraft, the bombers were also at liberty to machine-gun the fire-fighters who were trying to deal with the blazes (above) and emergency workers helping casualties (right).

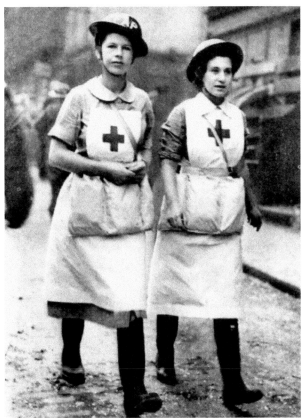

Bath from Beechen Cliff.
Publ. by R. Wilkinson & Cº, Trowbridge.

Worst-Affected Areas

The Royal Crescent appears to have been one of the targets but most bombs overshot the mark with nearby Julian Road (below) taking most of the punishment. The gasworks between the Upper and Lower Bristol Roads were also hit, creating fires that seemed to light up the whole of the city. The Hurricane night fighters of 87 Squadron based at Charmy Down along with aircraft from other nearby RAF stations were scrambled but made little impact. Eventually the raiders departed and the people of Bath emerged to review the carnage and aid the injured as best they could. Above, a pre-war colour postcard of the city.

120

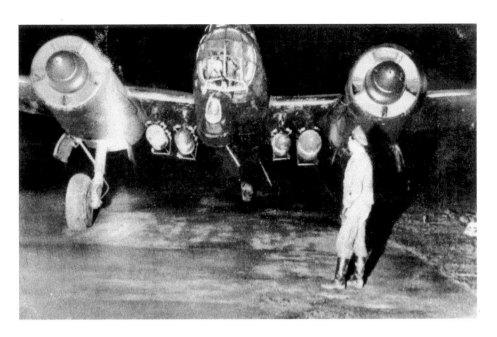

The Second Attack

Shortly after 4.30 in the morning, refuelled and rearmed, over forty raiders reappeared over the rooftops to perpetrate the second attack. Above we see one of the German bombers preparing to take off again. This time as the sirens wailed the people of Bath took immediately to the shelters as the city was subjected to another brutal pounding. The local RAF units were again called to action stations but with no greater success than during the previous onslaught. Oldfield Park (below) was among the worst-affected areas on this occasion, with seventeen people killed in one air-raid shelter alone.

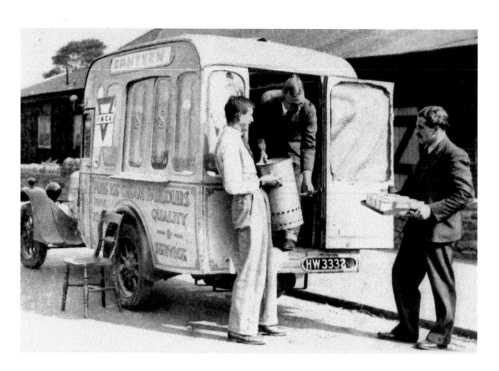

Coping with the Destruction

Rescue workers from all over Somerset and beyond descended on the scene. Damage to pipes and cables left many homes without gas or water. Emergency feeding stations were arranged by the Civil Defence and mobile canteens served tea and sandwiches to both the homeless and rescue workers alike. The Home Guard was sent to protect damaged banks and shops from looting and all through the day buses and lorries ferried bombed-out citizens to rest centres outside the city. Above we see a typical mobile canteen and below people at one of the rest centres.

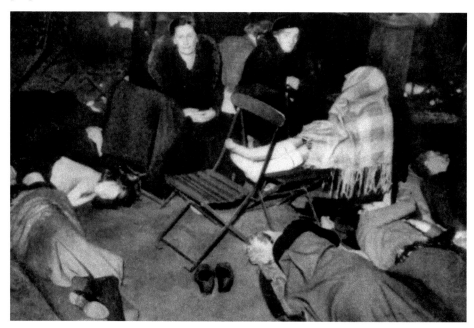

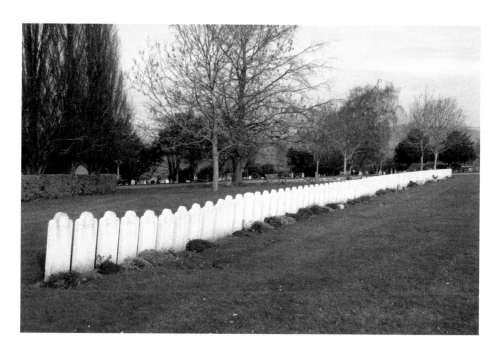

The Final Attack

The third and final attack took place early the following morning, Monday 27th, when around eighty bombers compounded the devastation for another hour and a half, again attacking at low level and again seemingly at will. The all-clear eventually sounded at 2.45. Over the course of the three raids an estimated 417 people were killed with another 900 or more injured. Many of the dead were buried at Haycombe Cemetery (above) and a memorial listing the names of the victims is now mounted on the war memorial at the entrance to Royal Victoria Park (below).

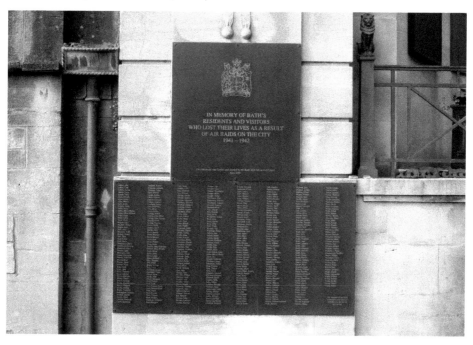

IN MEMORY OF BATH'S
RESIDENTS AND VISITORS
WHO LOST THEIR LIVES AS A RESULT
OF AIR RAIDS ON THE CITY
1941 – 1942

Bath's Heritage Survives

If Hitler's plan had been the destruction of this majestic city, his attempt was a failure, as most of the bombs had fallen on residential suburbs. Although a number of historic buildings did suffer considerable damage, in most cases it was rectifiable with time. Bath arguably suffered its most significant loss when the elegant Assembly Rooms built in 1771 were totally gutted by fire. It would take years of hard work and wrangling over compensation for the city to fully recover. Above we see the Abbey and below the Assembly Rooms today.

One Person's Memories of the Blitz

The photographs on this page show staff and patients at the Bath & Wessex Orthopaedic Hospital taken during the war. Elizabeth Wilbourne, who provided them, was on duty that night and says: 'I remember putting my tin hat over my cap and grabbing a bucket of sand and running to the end of the ward, which I thought was on fire, only to discover the flames were coming from the gasworks on the Lower Bristol Road. We put the children on their mattresses under the long ward table or under their beds to protect them from falling debris. We had no air-raid shelters. This is how they slept for many nights.'

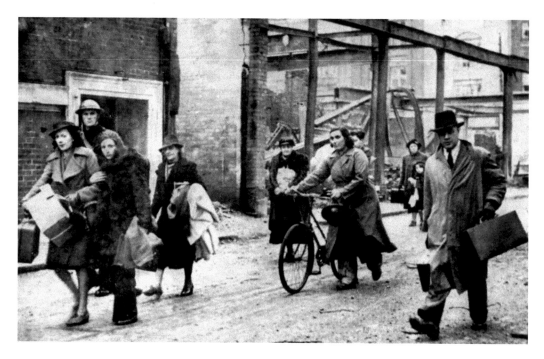

Trekkers Leave the City

Following the attacks many residents who became known as trekkers would flee from the city each night to search for safe havens away from the bombs (above). They would sleep in barns, under hedgerows, or anywhere else where they could find shelter, returning home or to work the following morning. This went on for some time, and although the local air defences would be bolstered against future attacks, Bath was never bombed again and today remains one of the most complete and beautiful Georgian cities in Britain (below).

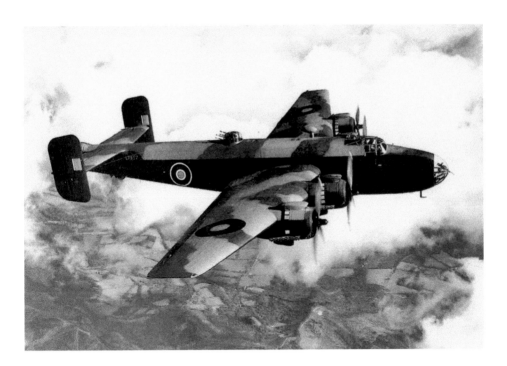

Last Serious Accident

By the end of the war a total of 668 people had been killed in Somerset due to enemy action. The final civilian fatality was on 15 May 1944 when bombs fell on Wincanton. The last accident involving serious loss of life was on 21 November 1944, when the seven-man crew of a Halifax bomber (above) were killed as their aircraft came down in a field at Long Ashton after taking off from RAF Blyton in Lincolnshire. A memorial in the churchyard now lists the names of the seven Polish airmen who died (below).

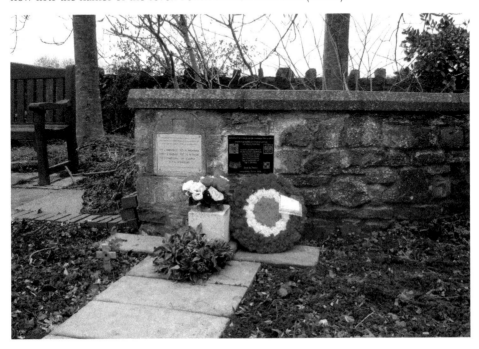

In Time to Come

In telling the story of Somerset at War we have visited many different places. We could have included many more but it would be impossible to list every bomb that fell, every aeroplane that crashed, or every person who died. I hope, therefore, to have given you a good summary of what was going on at the time. A suitable place to end our tour is Burrow Mump, where a plaque states: 'This hill was given to the National Trust, that the men and women of Somerset who died in the Second World War may be remembered here in time to come.'